No Substitute

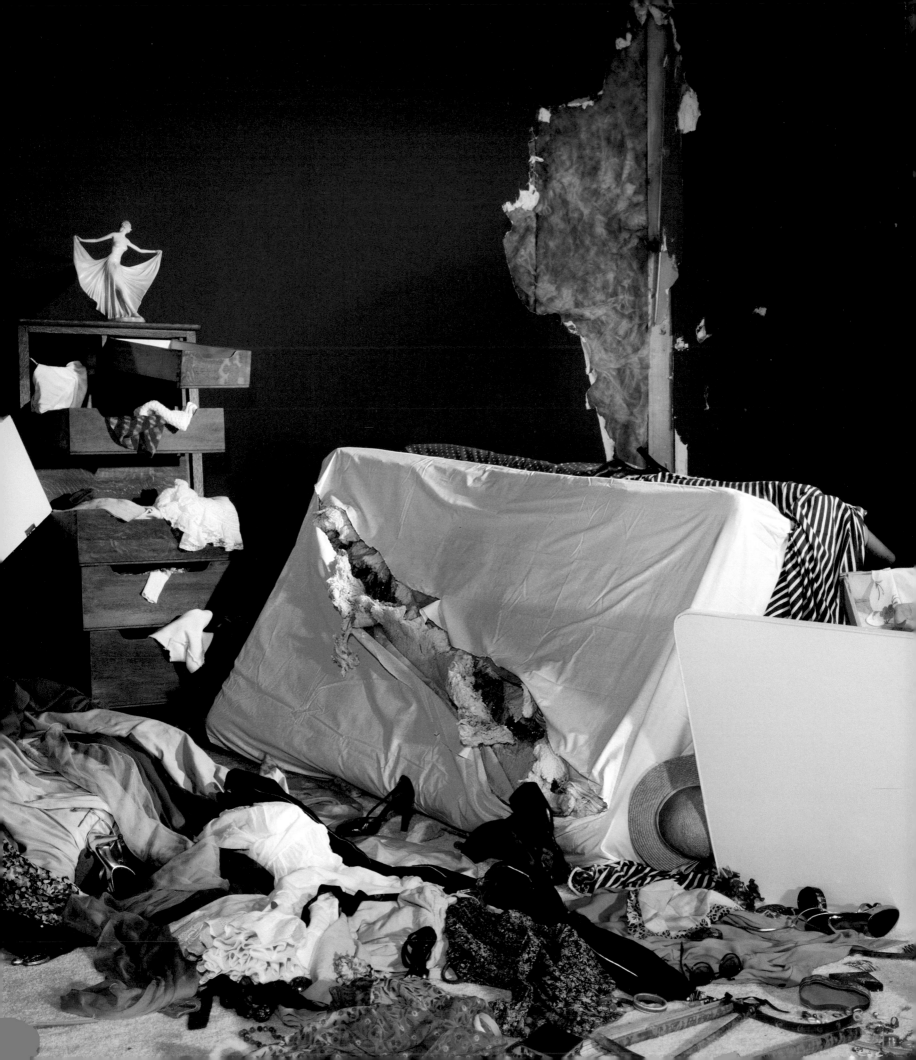

No Substitute

Glenstone
April 2011–January 2013

Jack Bankowsky
Emily Wei Rales

Published on the occasion of the
exhibition *No Substitute* at Glenstone,
April 2011–January 2013

Curator: Emily Wei Rales
Designer: Margaret Bauer
Text Editor: Eric Banks
Copy Editor: Kelli Rae Patton

Typeset in The Sans and Futura,
and printed on Phoenix Motion
Xantur.

Color separations and printing
by Meridian Printing,
East Greenwich, Rhode Island

Published by
Glenstone Foundation
12002 Glen Road
Potomac, Maryland 20854
www.glenstone.org

First Edition © 2011 Glenstone
Foundation, Potomac, Maryland;
"Ghost Studies" © 2011
Jack Bankowsky

ISBN: 978-0-9801086-2-0

frontispiece: Jeff Wall, *The Destroyed
Room* (detail), 1978 (no. 30)

Contents

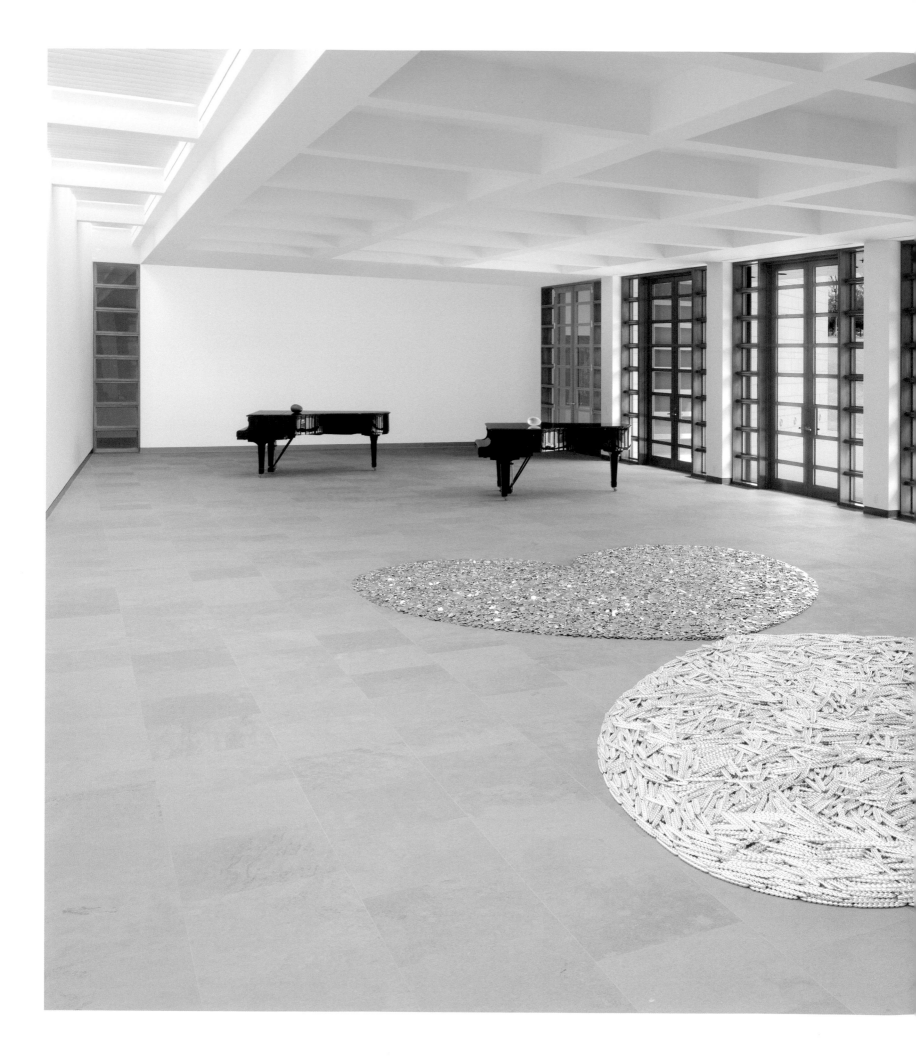

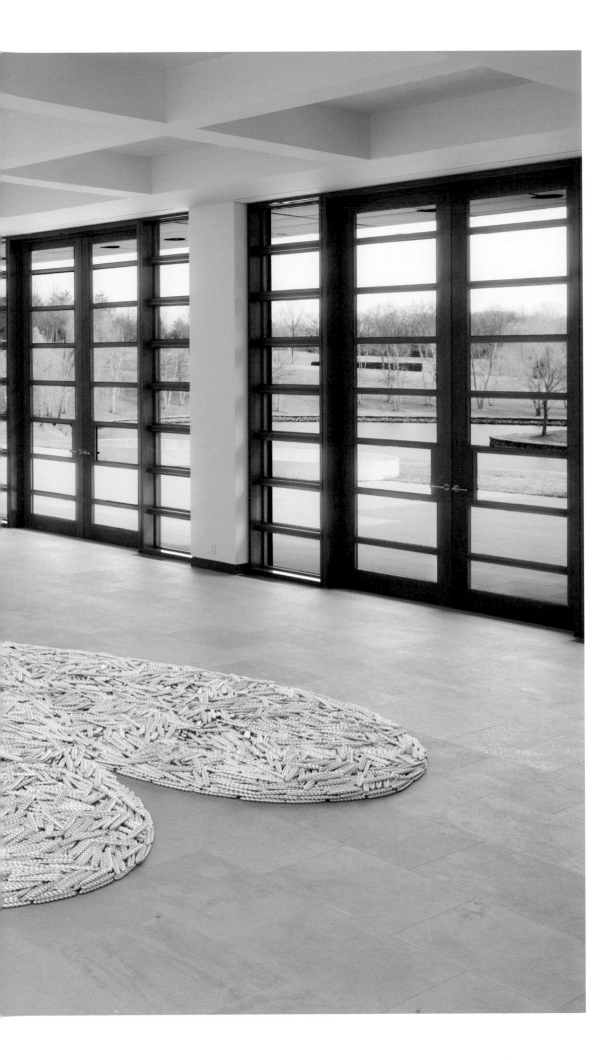

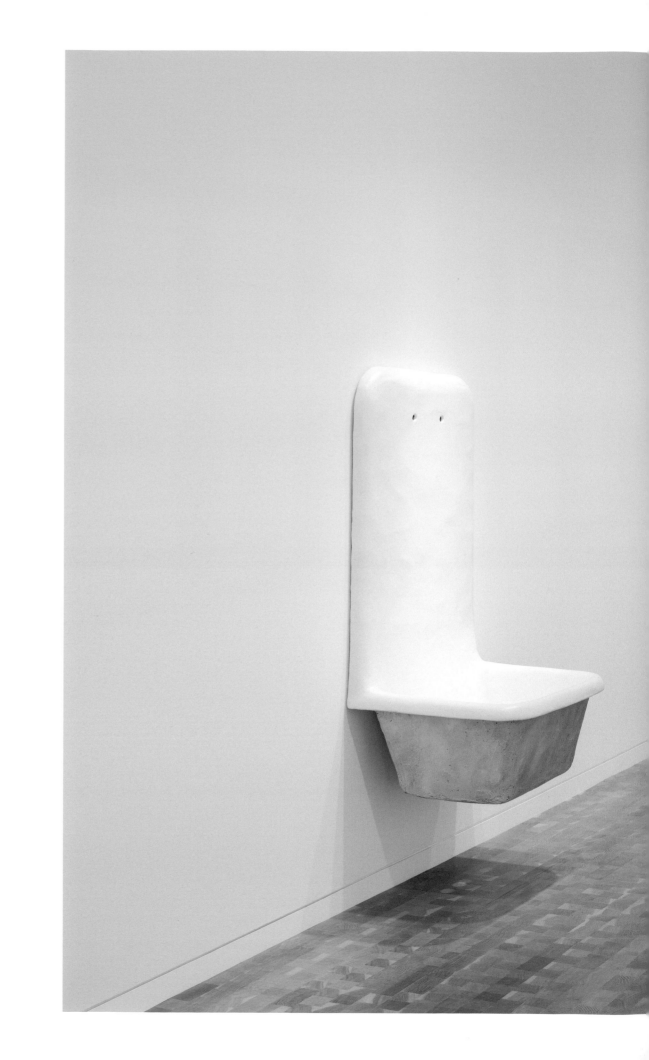

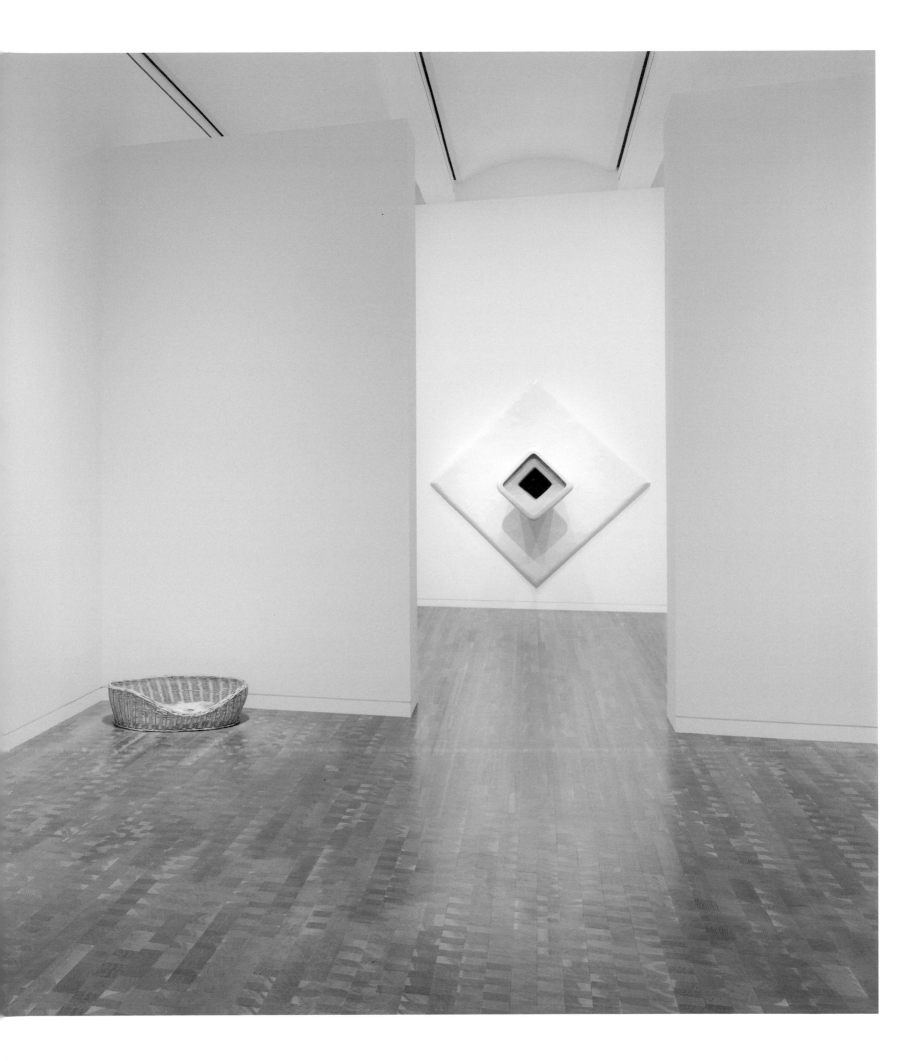

Foreword and Acknowledgments

Emily Wei Rales and Mitchell P. Rales

Five years into its history Glenstone is proud to present *No Substitute*, an exhibition of photography and sculpture by artists who have expressed a renewed interest in representation over the past three decades. This, our third exhibition, is also the final installment in a chronological tour through the collection that began in 2006, with the inclusion of Henri Matisse's 1910 bronze bust of Jeanne Vaderin, *Jeannette I*, in our inaugural exhibition. The works in *No Substitute* demonstrate how far the collection has expanded over the years, as our attention has turned increasingly toward artists active in the contemporary period such as Peter Fischli and David Weiss. We commissioned their sprawling installation, *The Objects for Glenstone*, more than two years ago, and have had the pleasure of watching it develop over the course of several visits to the artists' studio in Zurich. The opportunity to engage with artists like Fischli and Weiss has been one of the most rewarding aspects of bringing contemporary art into the Glenstone collection, so while there are many people to acknowledge in mounting an exhibition, we would like to thank the artists, first and foremost, for their creativity, insight, and wisdom. Their dedication inspires our own, and encourages us to continually rethink and define the collection in new ways. Of the artists included in this exhibition, we are especially grateful to David Weiss and Charles Ray, who came to Glenstone in person to install their works. We would also like to thank Jason Klimatsas, Mark Rossi, Alexander Clarke, Bill Abbott, Ryan Hart, Stephanie Dorsey, Mike Russell, Emily Tellez, Willy Yowalski, Ivo Morales, and Scott Patti for their assistance in facilitating a smooth installation.

We owe a great debt to Jack Bankowsky, whose insightful essay appears in this catalogue. Thanks are also due to Eric Banks and Kelli Rae Patton for their editorial guidance, to catalogue designer Margaret Bauer, and to Danny Frank of Meridian Printing for their work in once again producing an extraordinarily beautiful book.

We would like to acknowledge the hard work of many dedicated people at Glenstone. Maria Gabriela Mizes, registrar, masterminded the logistics of ensuring the artworks' safe passage in and out of the galleries. Maintenance associate Russell Ferreira attended to every aspect of the lighting and electricity, while estate manager Anthony Cerveny oversaw all necessary construction. Curatorial assistant Paige Rozanski coordinated schedules and countless details related to the exhibition. Appreciation is owed to Anne Reeve, curatorial research assistant, for conducting interviews with several artists in the show and for her fine editorial assistance on this book, as well as to Alexandra Small, archivist, who supervised photography and secured copyright permissions for this publication. In visitor services, the research assistance of Jamin An and Suzanne Gold merits recognition, as does the diligent help of curatorial intern Ben Benus. Additional thanks are due to Glenstone associates Latricia Friend, Rick Boger, Jason Muzzey, Rob Unglesbee, Dimitrios Fowler, Andrew Cunningham, Howard Weisman, Denis Juresic, Peter Downs, Valli dell'Acqua, and Suzanne Sabbatini for rising beyond the call of duty during our busiest time.

We salute Christian Scheidemann for attending to the condition and safety of the works in the exhibition with utmost care; Eric Gravley, Bruce Liffiton, and Nick Gay of Planet Vox, for behind-the-scenes videography; Tim Nighswander and Andrés Garcés, for photography of the artworks and installation; Zack Zanolli and Courtney Yip of Fisher Marantz Stone for lighting design; Bill Butler of Archival Art Services for framing; and Bruce, Jake, and Libby Thiel of Blueline Design for silkscreening the wall texts.

Finally, we would like to acknowledge the following gallerists and advisers for their assistance in securing the artworks in the exhibition: Doris Ammann, Kristine Bell, Mary Boone, Paula Cooper, Georg Frei, Barbara Gladstone, Marian Goodman, Sandy Heller, Steve Henry, Dominique Lévy, Robert Mnuchin, Manuela Mozo, Janelle Reiring, Helene Winer, and David Zwirner. Most of all, we are indebted to Matthew Marks, whose continued support has enabled Glenstone to acquire some of the most important works in the collection, many of which were critical to the realization of this show.

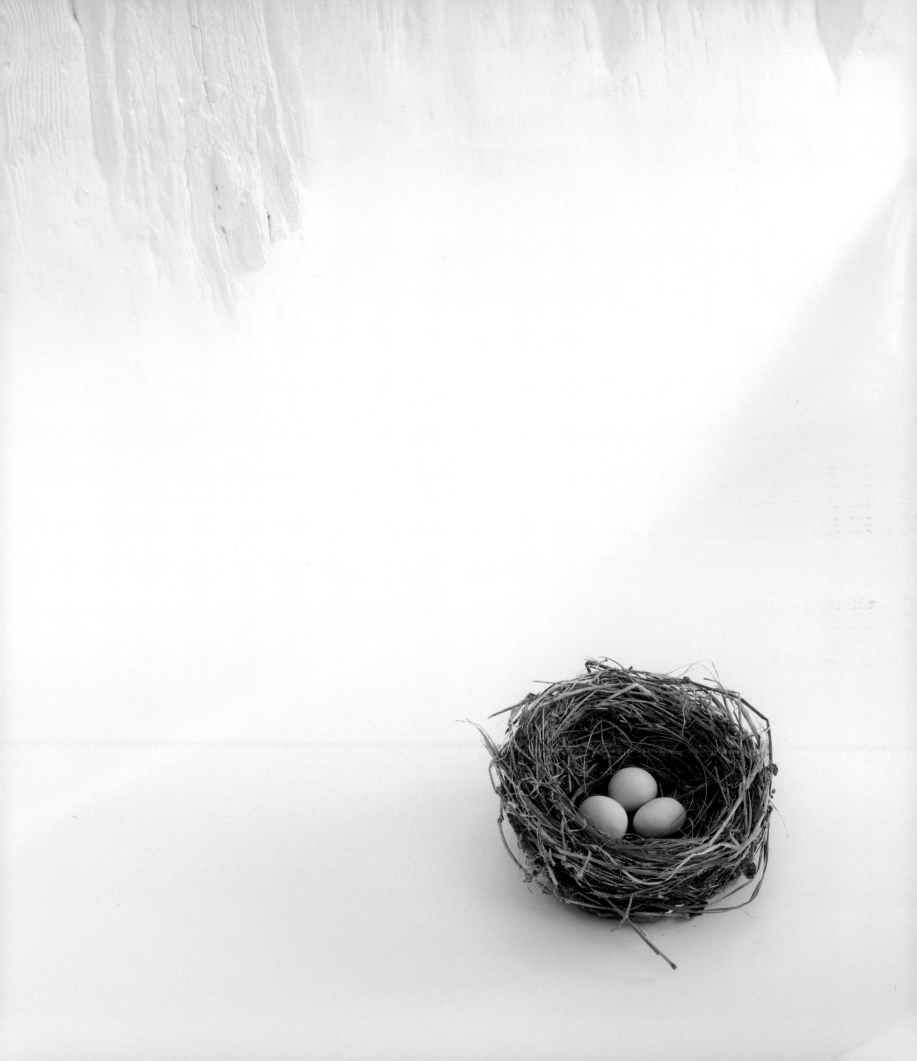

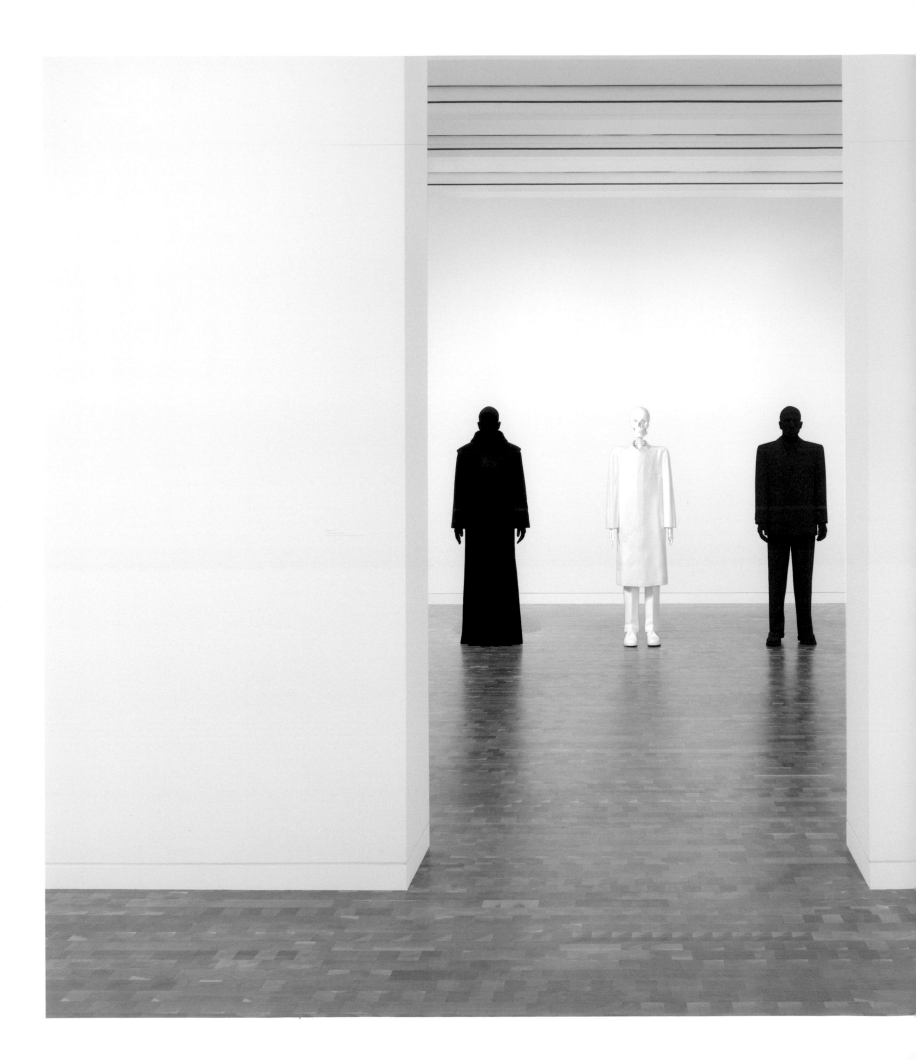

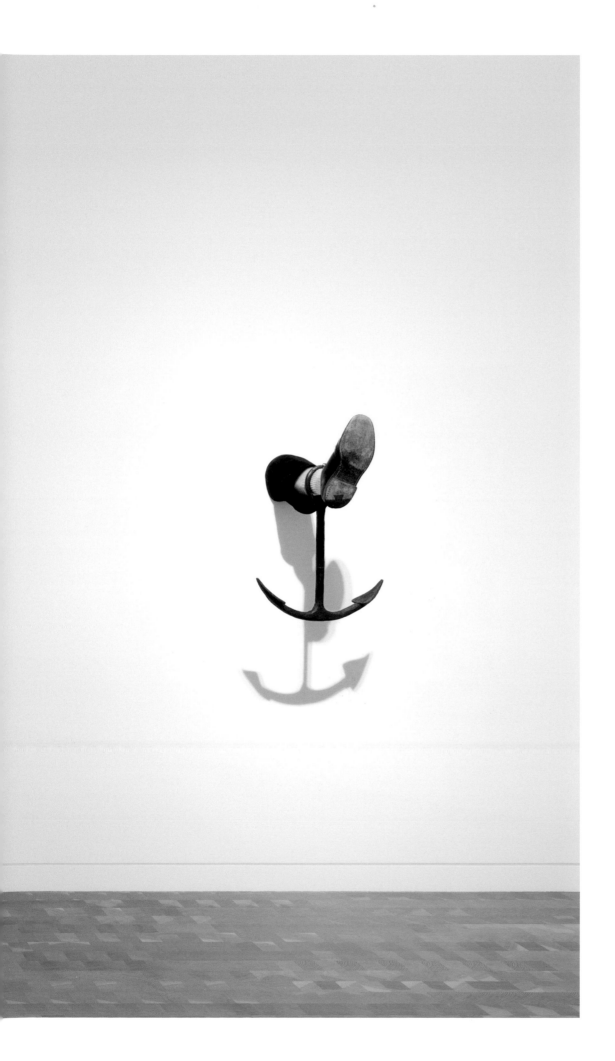

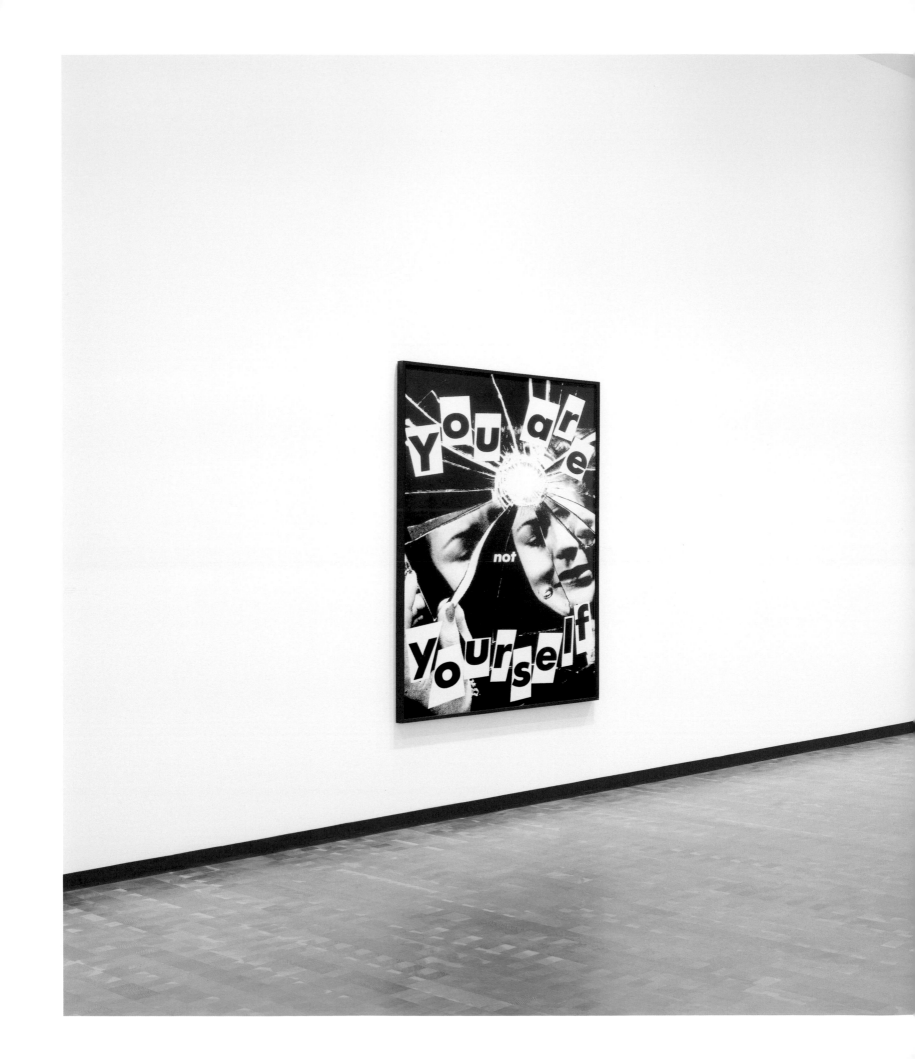

Emily Wei Rales

Introduction

Glenstone's third exhibition takes its name from a 1981 collaboration between American artists Sherrie Levine and Louise Lawler, titled *A Picture Is No Substitute for Anything*. This roving curatorial project focused its attention on the marginalization of art of a certain conceptual bent during the art market boom of the 1980s, and with it the artists produced a series of memorable announcement cards and press releases. In our exhibition, the abbreviated title expands its frame to reference the simulacra, appropriated imagery, and unattributed quotations that figure so prominently in art of the past three decades. Though at times it may appear otherwise, the works in *No Substitute* are not mere copies. Their makers go to great lengths to alter, augment, and transform their source material, demonstrating a painstaking artifice that is at times astonishing to behold and provocative in its own right.

 Although Marcel Duchamp's work is not presented here, his influence pervades the exhibition. In 1917, Duchamp submitted a white porcelain urinal to the annual exhibition held by the New York Society of Independent Artists as a "readymade"— a term he coined to describe an industrially produced object selected and presented as art but otherwise untouched by the artist's hand. Signed and submitted under the pseudonym "R. Mutt," the urinal was considered immoral and was promptly removed by the exhibition's organizers. However, in presenting his first readymade in public, Duchamp had challenged the traditional values of authenticity, authorship, and craft that were then commonly ascribed to art. In doing so, he changed the course of art history.

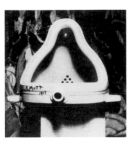

Alfred Stieglitz, *Fountain*, photograph of sculpture by Marcel Duchamp, 1917, Succession Marcel Duchamp, Villiers-sous-Grez, France

At the hands of the twelve artists in *No Substitute* the act of repetition and Duchampian re-presentation bestows objects and images with additional layers of meaning, as if to take umbrage at Walter Benjamin's famous claim that the unique presence of an authentic work of art—its "aura," in his parlance—is lost in reproduction.[1] Our exhibition looks at the unexpected reversal whereby a copy acquires a presence that overshadows its model. The show examines how a generation of artists, who came of age in a postwar culture saturated with mass media imagery, engages this phenomenon to destabilize notions of originality, question conventional truth criteria, express ambivalence about the status of art as a commodity, and comment on the individual's political, social, and psychological relationship to images and objects.

The date of the earliest work in the exhibition, an *Untitled Film Still* (no. 28) by Cindy Sherman, coincides with the 1977 exhibition *Pictures* at New York's Artists Space. Although this exhibition featured only four artists (including Levine, whose works are also on view at Glenstone), "Pictures" became popular shorthand for a group of New York–based artists working in a mode of "quotation, excerptation, framing, and staging," where "underneath each picture there is always another picture."[2] Critical accounts of this period often cite the influence of freshly translated French post-structuralist theory, such as the landmark essay "The Death of the Author" by philosopher Roland Barthes. In it Barthes argues that any text is but a "tissue of signs," composed of quotations from other texts, whose author is no more than a construct and whose true meaning is decoded only by the reader.[3]

The Pictures artists worked in a variety of media but none became more closely associated with the group than photography, which facilitated an easy appropriation of popular imagery. In the current exhibition, we see how artists like Richard Prince and Barbara Kruger rephotographed images from existing sources in order to present them anew, generating a dizzying rabbit's hole of reduplication. Not only does the rephotographed image double that of the original, each work contains its own doubles, from Prince's "gang" of identically posed fashion models (no. 25) to the splintering of one woman's mirrored reflection in Kruger's photomontage, *Untitled (You Are Not Yourself)* (no. 16). Whereas Prince's women are frozen and mute, Kruger's is accompanied by an aggressive text set in a bold typeface intended to parody media headlines. As critic Craig Owens has observed, Kruger uses a highly legible font in order to interrupt the viewer's passive absorption of image stereotypes that saturate contemporary society.[4] Kruger's text first appears to link a fractured reflection with a woman's schizophrenia, conjuring the cliché of the female hysteric. Yet the "You" and "Yourself" remind us of our responsibility, as Barthesian readers, to participate actively in producing the work's meaning. Another artist investigating the construction of female identity is Cindy Sherman, whose *Untitled Film Stills* are perhaps the most frequently cited works in feminist art discourse on the period. The series portrays Sherman enacting a variety of roles plucked from postwar European cinema with a virtuoso-like talent. Taken as a whole the *Untitled Film Stills* reveal the many facets of female identity and how stereotypes inflect our understanding of it.

Though unaffiliated with the Pictures artists, Jeff Wall also turned to cinema and popular media when charting a new course with his photography. Wall has

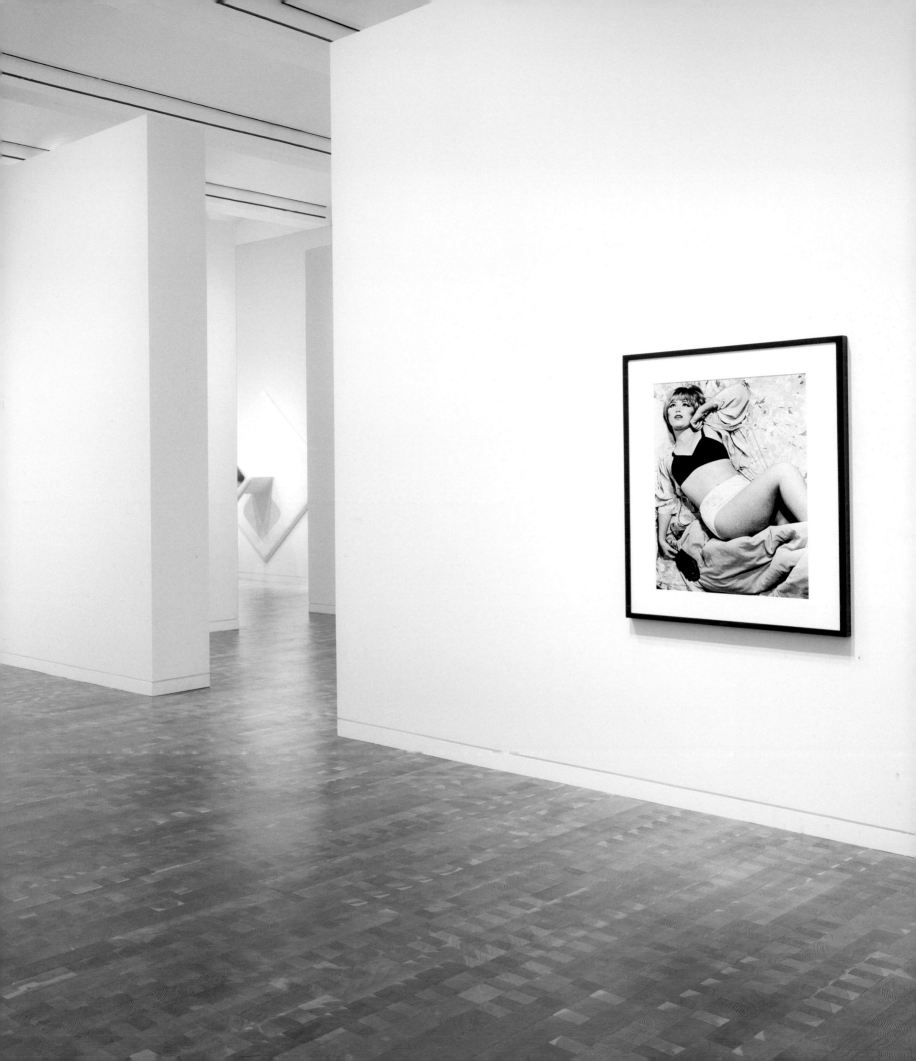

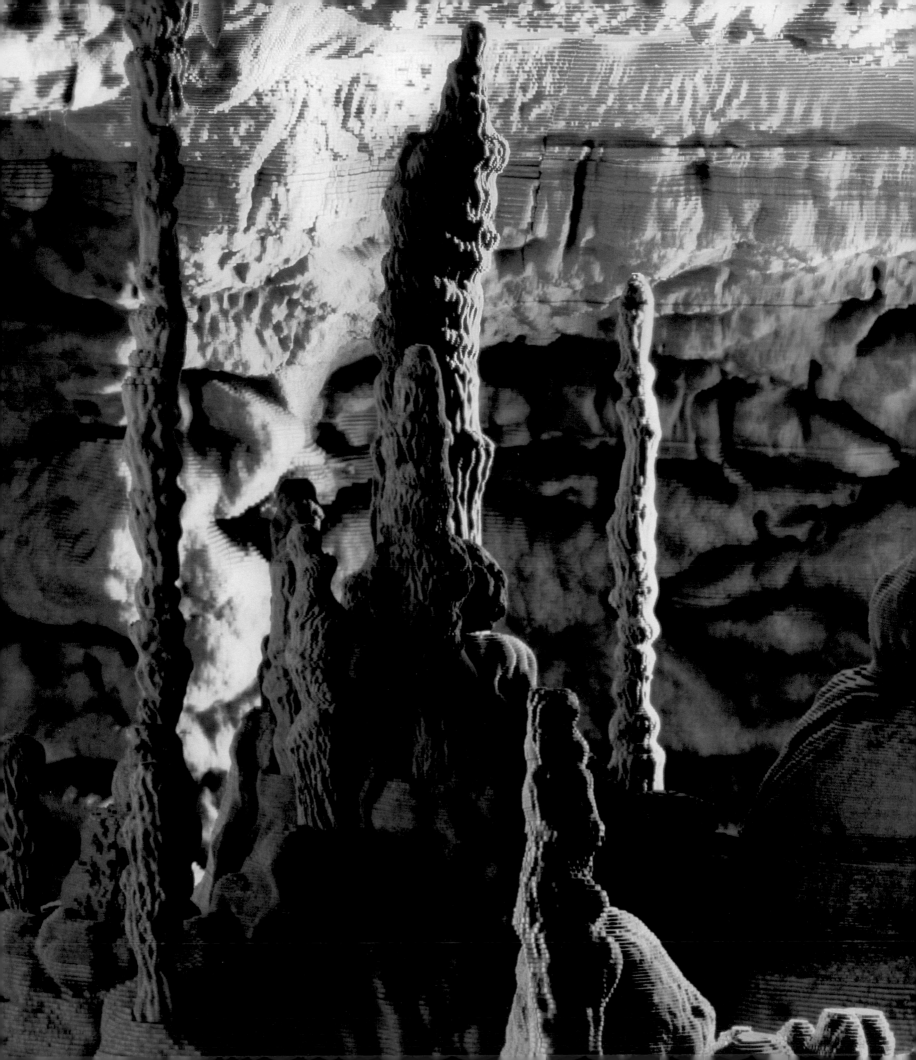

described his role as a "painter of modern life,"[5] extending the lyrical possibilities of photography to chronicle the everyday human condition in the tradition of Western pictorial art. He blends elements of painting, cinematography, and photography to produce typically monumental pictures that are either staged, documentary, or a hybrid classification that the artist calls "near-documentary." While all three modes are presented at Glenstone, Wall tends to avoid differentiating among them, maintaining that the origins of a picture have little to do with how it is received. Wall's first work in the tableau genre was also the first that he chose to produce as an illuminated transparency inside a light box, a format that recalls outdoor advertising displays as much as it does movie screens. Made using a large-format camera, *The Destroyed Room* (no. 30), captures minute details inside a ravaged, anonymous room. It also makes reference to *The Death of Sardanapalus* (1827), Eugène Delacroix's narrative painting depicting the Assyrian king who, upon learning his palace was to be invaded by enemy forces, ordered his possessions destroyed and his concubines massacred. Through subtle tactics such as theatrical lighting and the sliver of a brick wall visible from behind a doorway, Wall reveals the scene to be an elaborately constructed stage set. In a more recent work Wall returns to the theater motif in a more traditional documentary fashion, turning his lens toward the side of a building that is normally overlooked. *Rear view, open-air theatre, Vancouver* (no. 32) is a study in color and geometry as deliberately composed as any of his cinematographic pictures. Finally, Wall achieves a seemingly perfect "fusion of reportage and the imaginary"[6] in *An Eviction* (no. 31), for which he hired amateur actors to restage an event he witnessed in person. Its panoramic scale rivals that of nineteenth-century history paintings and is attended by a similarly immersive quality. The eye wanders to take stock of each detail, but it is impossible to ascertain which faithfully reproduce the actual event and which are fabrications of Wall's design.

Thomas Demand often works with images from the public domain, which in turn inspire life-size, three-dimensional models the artist constructs out of paper to invoke desolate spaces and commonplace objects. He then uses a high-resolution camera and studio lighting to photograph the models, which he then destroys. What remains of this laborious process is the final artwork: eerily realistic images that betray a patent artificiality—for example, the seams holding together individual pieces of colored paper in Demand's models are clearly visible. *Leuchtkasten* [Light Box] (no. 1) depicts a light box similar to those that illuminate Jeff Wall's pictures, and advances Demand's trompe l'oeil technique one step further by creating the illusion that this is a partially installed piece by Wall himself. When we realize that it is not, in fact, a row of fluorescent tubes but a photograph, we are met with a second surprise—that the lights, ballasts, and wires depicted in the image are in fact made out of paper. *Grotto* (no. 2) marks the artist's first use of digital technology, but not in the use of digital photography as one might expect. Instead Demand devised a computer program to generate and cut the forms of his model, which was based on a grotto pictured on a postcard from Majorca. The model was rendered in strata, like a three-dimensional topographical map, and required more than one hundred thousand pounds of paper to build. Hoping to translate "the digitalised world . . . into reality,"[7] here Demand consolidates the natural and artificial into a single, arrestingly complex image. His

unique process, one that is equal parts sculpture and photography, assimilates the familiar and returns it to the world newly estranged.

A sense of estrangement also infuses the work of Katharina Fritsch. *Mönch* [Monk], *Doktor* [Doctor], and *Händler* [Dealer] (nos. 4–6) form a haunting trio of "bad men" and embody the sinister aspects of the institutions they represent. Fritsch's figures share the same space and scale as the viewer, yet simultaneously conjure an otherworldly realm. She achieves this disquieting verisimilitude in part through her use of materials, building layer upon layer of monochromatic pigments into a saturated, almost velvety surface that never reflects its surroundings. Her emblematic use of color—black for *Mönch*, white for *Doktor*, and red for *Händler*, as well as certain unforgettable details, like the *Händler*'s single cloven foot, leave no question as to the ulterior motives of these villainous apparitions. While *Händler* hints at Fritsch's interest in the role of art in a market economy, she further explores the medium of exchange value itself in *Herz mit Geld and Herz mit Ähren* [Heart with Money and Heart with Wheat] (no. 7). This floor-based work consists of two identical heart-shaped fields piled high with thousands of individual metallic pieces, in the form of silver coins on one side and gold sheaths of wheat on the other. The mounds overflow with luxurious abundance, and the bright luster of gold and silver give the work a mesmerizing allure. The sculpture's reflectivity, like the shimmering, fluctuating surface of water, almost has the effect of dissolving its materiality. Fritsch speaks about her works as three-dimensional pictures, miragelike and hallucinatory, one moment existing squarely in front of the viewer with weight and density, and the next moment becoming no more than a visual imprint.[8]

Since the early 1990s Sherrie Levine has appropriated motifs from art historical sources as the basis for her sculptures. Levine's *Fountain (After Marcel Duchamp): 1* (no. 22) names the artist to whom she pays homage and the work that revolutionized modern art. Yet her *Fountain* gleams in polished bronze, recalling the work of Constantin Brancusi while transforming Duchamp's iconoclastic statement into a seductive fetish object. The resulting conflation of high art and kitsch is one of the artist's trademarks, also evident in the display of her *Newborns* (nos. 23–24). Levine made these pieces by casting Brancusi's marble sculpture (also called *Newborn*) first in milky white and then in black glass. Six of the white *Newborns*—the entire edition fabricated by the artist—made their debut in 1993 on identical grand pianos at the Philadelphia Museum of Art, in an installation that placed Levine's affinity for repetition center stage. While clearly owing a debt to the serial forms of Minimalism, Levine's particular brand of repetition compares mass consumer production processes with the practice of fabricating sculpture in editions, which dates back to well before Brancusi's time. The pianos are yet another reference to Duchamp, functioning as readymade pedestals that the museum procured from a local piano dealer according to Levine's instructions. That one *Newborn* of each color is shown at Glenstone encourages the comparison to decorative objects sold in a range of "colorways" designed to harmonize with one's furnishings.

A coupling of art and domesticity also pervades the work of Louise Lawler, Levine's erstwhile collaborator, who photographs other artists' works in galleries and

Katharina Fritsch
Herz mit Geld und Herz mit Ähren
[Heart with Money and Heart with Wheat]
(detail), 1998–99 (no. 7)

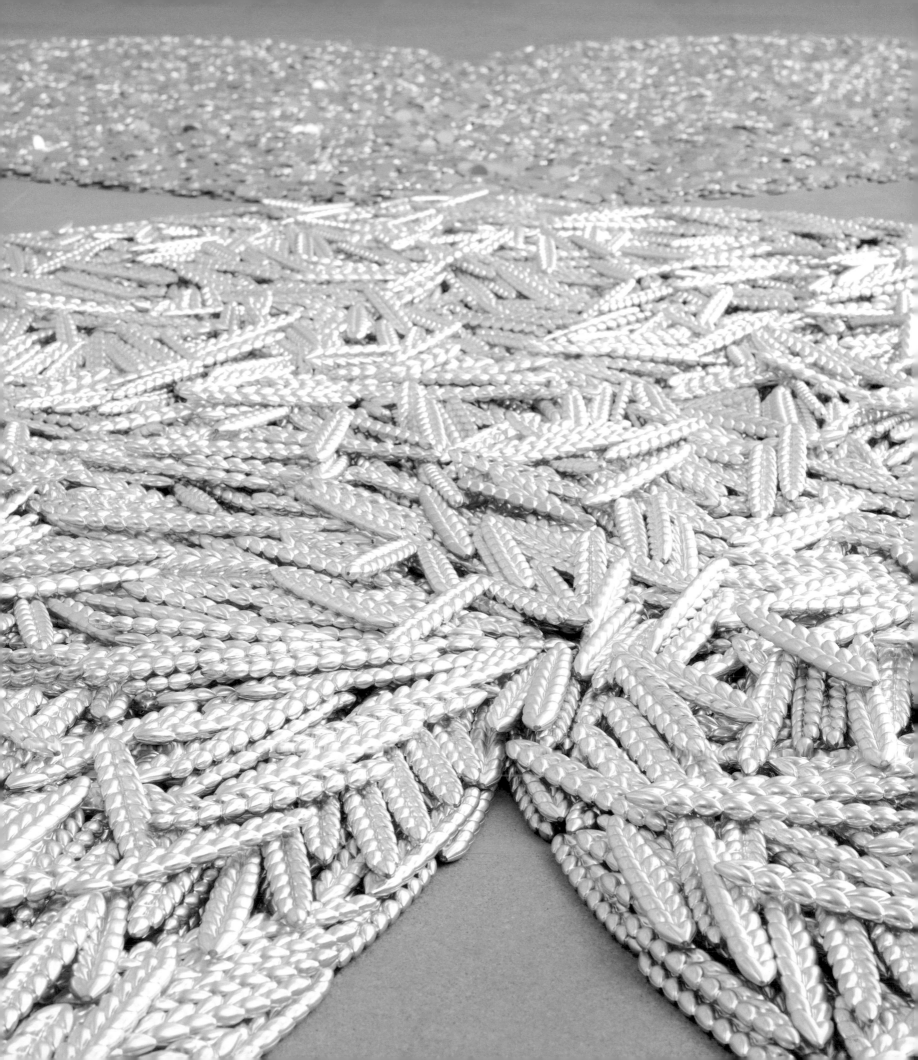

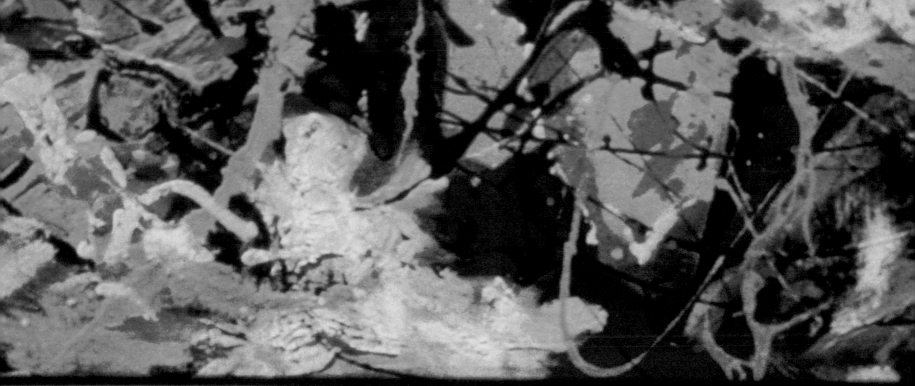
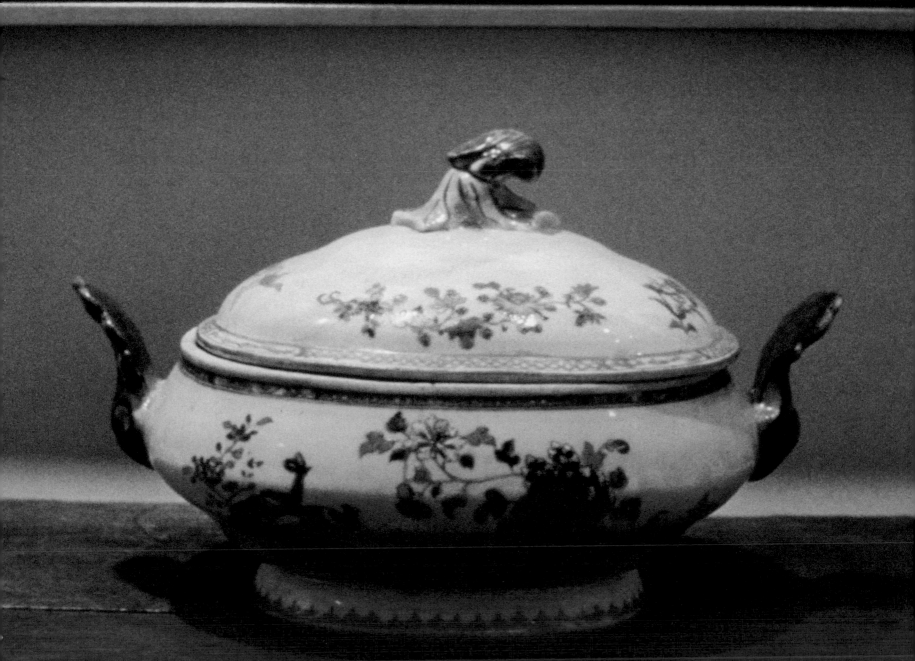

collectors' private residences. In chronicling these objects' circuitous journeys through the market, Levine calls attention to the role of patronage in shaping the way we interpret and understand art. Among the first collectors Lawler approached for this project were Burton and Emily Tremaine, who had at the time amassed what was widely considered to be one of the finest American collections of modern and contemporary art. Her 1984 photograph *Pollock and Tureen, Arranged by Mr. & Mrs. Burton Tremaine, Connecticut* (no. 18), taken in the couple's opulent home, reveals their penchant for color coordinating interior decor with such iconic masterpieces as Jackson Pollock's *Frieze* (1953–55). In 1988, Lawler returned to the Tremaines' story with a series of photographs taken at Christie's, where part of their collection was consigned for sale. Lawler's identical photographs *Does Marilyn Monroe Make You Cry?* and *Does Andy Warhol Make You Cry?* (nos. 19–20) show Warhol's *Head of Marilyn Monroe* (1962) next to a typewritten label tacked to the auction house wall. At Glenstone, the twin images hang side by side, distinguishable only with the help of two Plexiglas labels designed by the artist. While we can muse on the multiple layers of celebrity—from Monroe to Warhol and back again—that Lawler collapses into this image,[9] in its juxtaposition with *Pollock and Tureen* we are reminded of the dynamic history of the Tremaine collection, both at the height of its splendor as well as the moment of its dissolution. That *Frieze* is now part of the Glenstone collection—acquired from the collector who bought the painting at the same Christie's sale—adds another link to the provenance chain and extends Lawler's comment on the mutable nature of art's meaning as it is subjected to the laws of supply and demand.

We encounter Duchamp's legacy once again in the sculptures of Robert Gober, Charles Ray, and Peter Fischli and David Weiss. Like their antecedent, these artists import everyday objects into the museum and gallery setting. However, their works only appear to be readymades when they are, in fact, meticulously crafted replicas. Since the early 1980s Gober has been making sculptures of sinks and urinals that at first glance seem to be simple fixtures found in the local hardware store. Yet through subtle distortions and carefully worked, imperfect surfaces, we soon realize that the sculptures are handmade rather than cast, thus assuming an idiosyncratic and even anthropomorphic individuality. Body parts have populated Gober's imagery since the late 1980s, such as in *Leg with Anchor* (no. 14), a lifelike sculpture of a man's leg jutting out of the wall with an anchor dangling from the ankle. The body is exposed as abject and vulnerable, familiar yet strangely alien. In other works, Gober imbues inanimate objects with this same psychological frisson, pushing toward a realm of fantasy and horror: for example, an oversize mousetrap waits ominously inside a baby's crib in a sculpture entitled *Going For The Cheese* (no. 12). While the artist generally avoids discussing symbolism in his work, he describes the late 1980s and early 1990s as a dark time when so many lives were lost to the AIDS epidemic and so little was done to address it. Seen against this backdrop of loss and disillusionment, Gober's objects inhabit a place where private and political, unconscious and conscious, coincide.

While Charles Ray has often sculpted complex machinery, he maintains that it is the form rather than subject matter that is his primary concern. For *Untitled (Tractor)* (no. 27), Ray cast each of the several hundred individual components of a broken tractor in aluminum, a material he selected for its pliability, and then painstakingly reassembled the parts. Ideally, when revealed, this process slows down the act of looking by enhancing one's awareness of the extreme care and observation that went into their fabrication. Ray extends the duration of our experience, and in doing so invites us to relive the sculpture's making. We may even begin to perceive similarities between the tractor and our own bodies, for both move through space yet conceal the mechanisms that control and fuel their locomotion. When asked why he went to the trouble of casting so many individual parts when most are not immediately visible, Ray says, "I did that because I wanted to sculpt you, too," a telling remark from an artist whose interest in the relationship between objects and the human body, and how both are embedded in space, has driven his practice from the start.

For the past twenty years, among their diverse artistic pursuits, Peter Fischli and David Weiss have been carefully creating replicas of objects found in their studio out of rigid polyurethane foam, a material commonly used for insulation. These hand-carved and painted facsimiles are then arranged in compositions that evoke the artists' own cluttered work space. *The Objects for Glenstone* (no. 3) is a sculptural tour de force that took two years to complete and is composed of some several hundred individual pieces — their largest and most complex installation of polyurethane objects to date. The installation tempts a viewer to construct a narrative, though this exercise soon reveals moments of dissonance that thwart any successful attempt to do so. The arrangements are funny, disconcerting, and mysterious, like the low table scattered with children's toys and a pair of pliers (clearly unsafe for small hands), or a giant metal chain winding its way around a lilliputian armchair and ottoman set. Just as there is no clear story, the installation is not an exact copy of the studio, nor are the objects faithful replicas — one needs only to look at the handpainted Chips Ahoy! box to find dashes and dots in place of legible text. Fischli and Weiss allow for a good measure of difference between the real and the substitute, inviting us to fill in the gap with our imagination. Thus a paint-splattered plywood board can become an abstract painting à la Gerhard Richter, and a simply rendered wooden figurine might recall Paul Gauguin's sojourn in Tahiti.[10] The gesture of repetition invites us to contemplate objects as more than simple items of utility or even imperfect surrogates, but as things endowed with humor, poetry, and metaphor. If it is true that no one thing may substitute for anything else, then each object carries its own compelling array of possibilities.

1. Walter Benjamin, "The Work of Art in the Age of Mechanical Reproduction" (1936), in Walter Benjamin and Hannah Arendt, eds., *Illuminations: Essays and Reflections* (New York: Schocken Books, 2007), 221.

2. Douglas Crimp, "Pictures," *October* 8 (Spring 1979): 87.

3. Roland Barthes, "The Death of the Author" (1968), in *Image – Music – Text*, trans. Stephen Heath (New York: Hill and Wang, 1977), 142–48.

4. Craig Owens, "The Medusa Effect, or the Specular Ruse," reprinted in Scott Bryson, Barbara Kruger, Lynne Tillman, and Jane Weinstock, eds., *Beyond Recognition: Representation, Power, and Culture* (Berkeley and Los Angeles: University of California Press, 1992), 195.

5. Jeff Wall, "A Painter of Modern Life: An Interview Between Jeff Wall and Jean-François Chevrier," *Jeff Wall: Figures & Places: Selected Works from 1978–2000* (Munich, London, and New York: Prestel Verlag, and Frankfurt: Museum für Moderne Kunst, 2001), 175.

6. Ibid., 174.

7. Thomas Demand, "A Conversation Between Alexander Kluge and Thomas Demand," *Thomas Demand* (London: Serpentine Gallery and Munich: Schirmer/Mosel, 2006), 51.

8. Katharina Fritsch, "Thinking in Pictures," in *Katharina Fritsch* (New York: Matthew Marks Gallery, 2002), 98.

9. See Jack Bankowsky's insightful discussion of these and other works in "Does Louise Lawler Make You Cry?," in *Louise Lawler and Others* (Ostfildern-Ruit: Hatje Cantz and Basel, Kunstmuseum Basel, Museum für Gegenwartskunst, 2004), 75–90.

10. David Weiss, in conversation with the author, Potomac, MD, March 10, 2011.

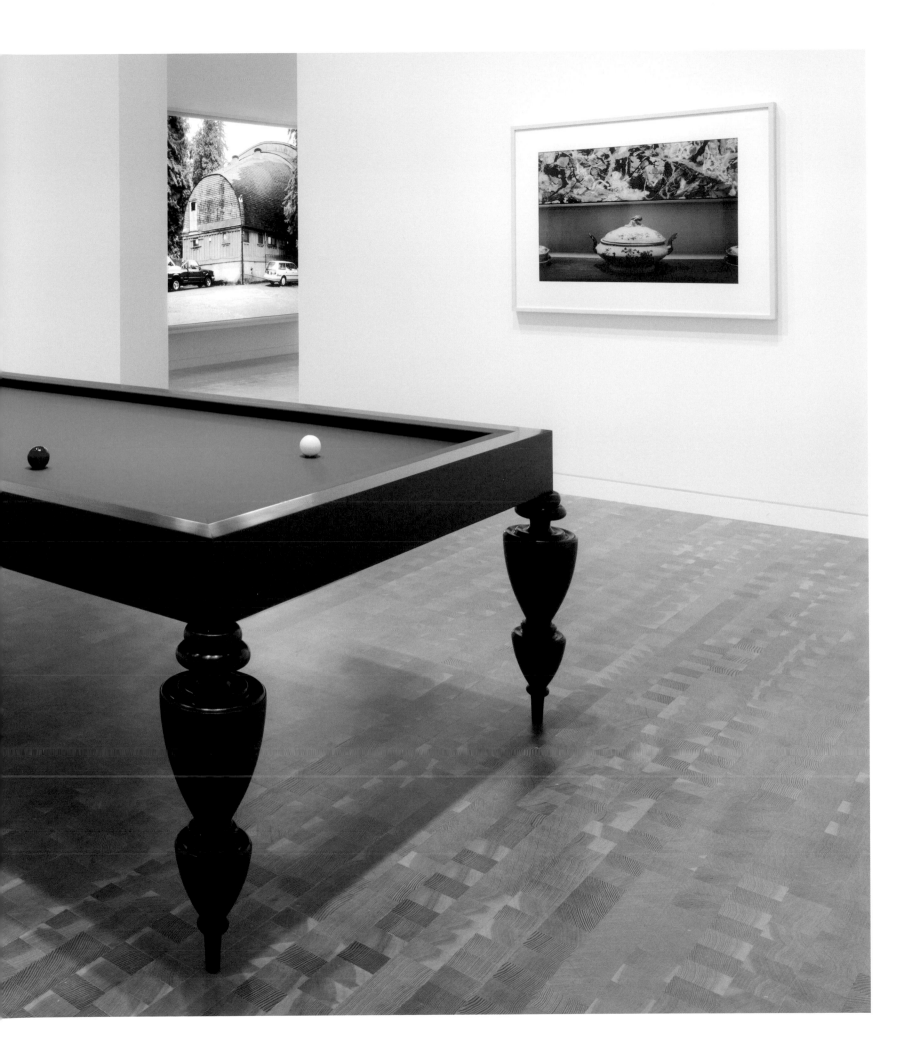

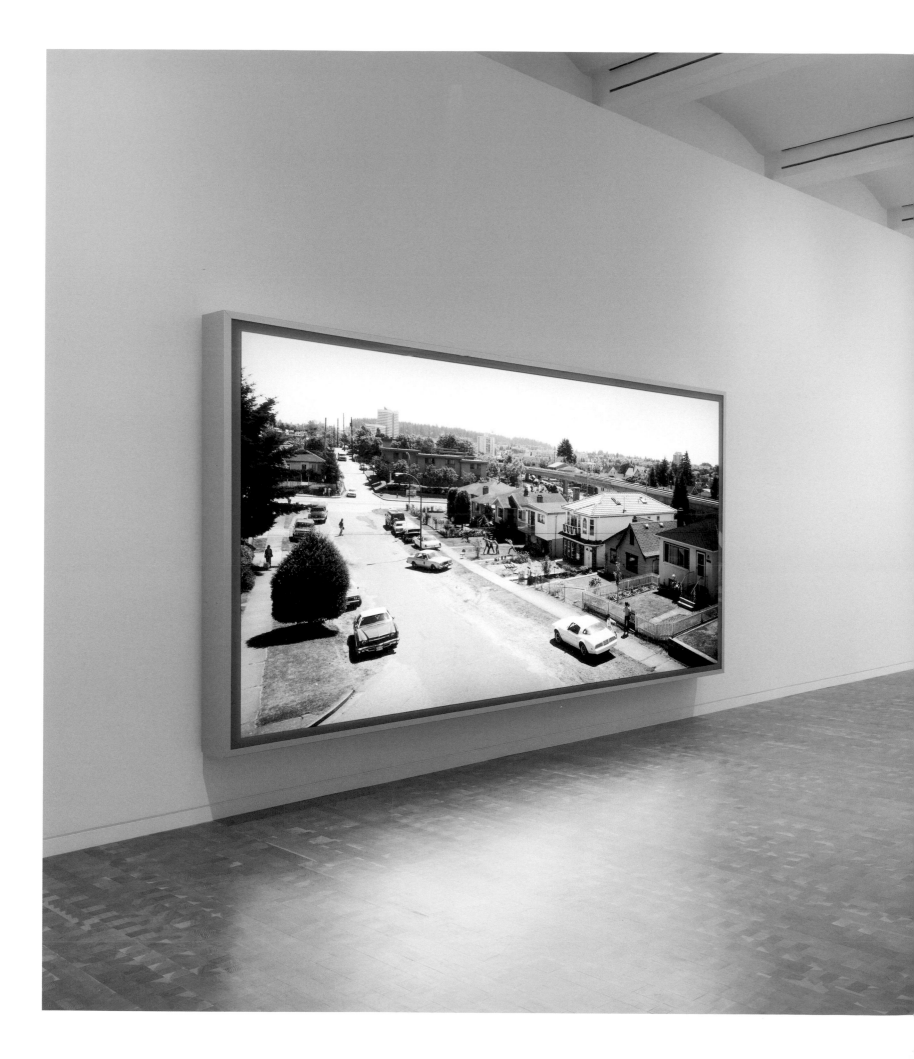

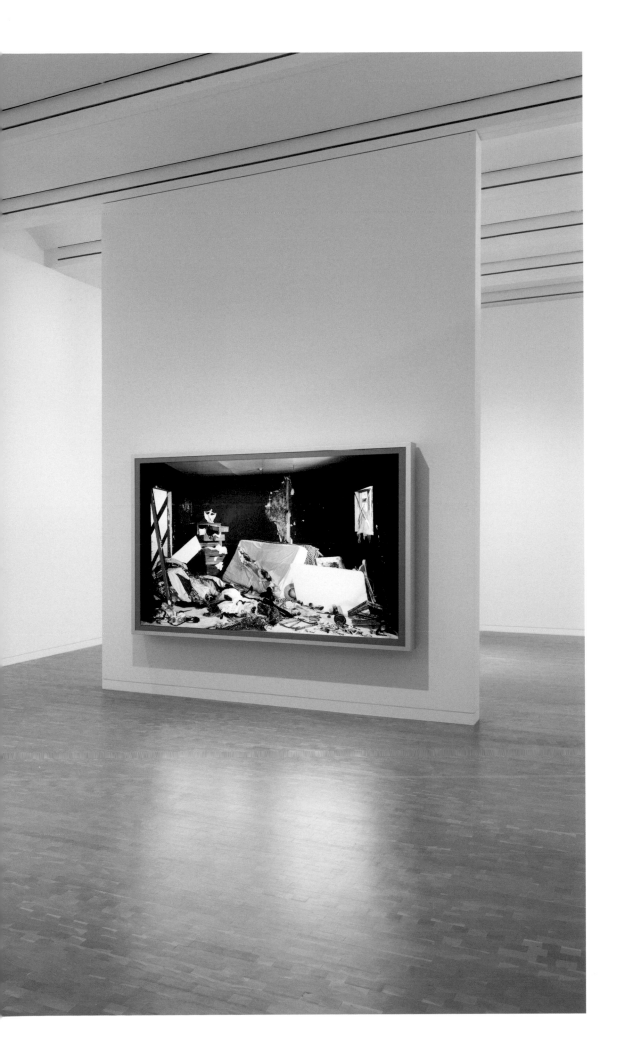

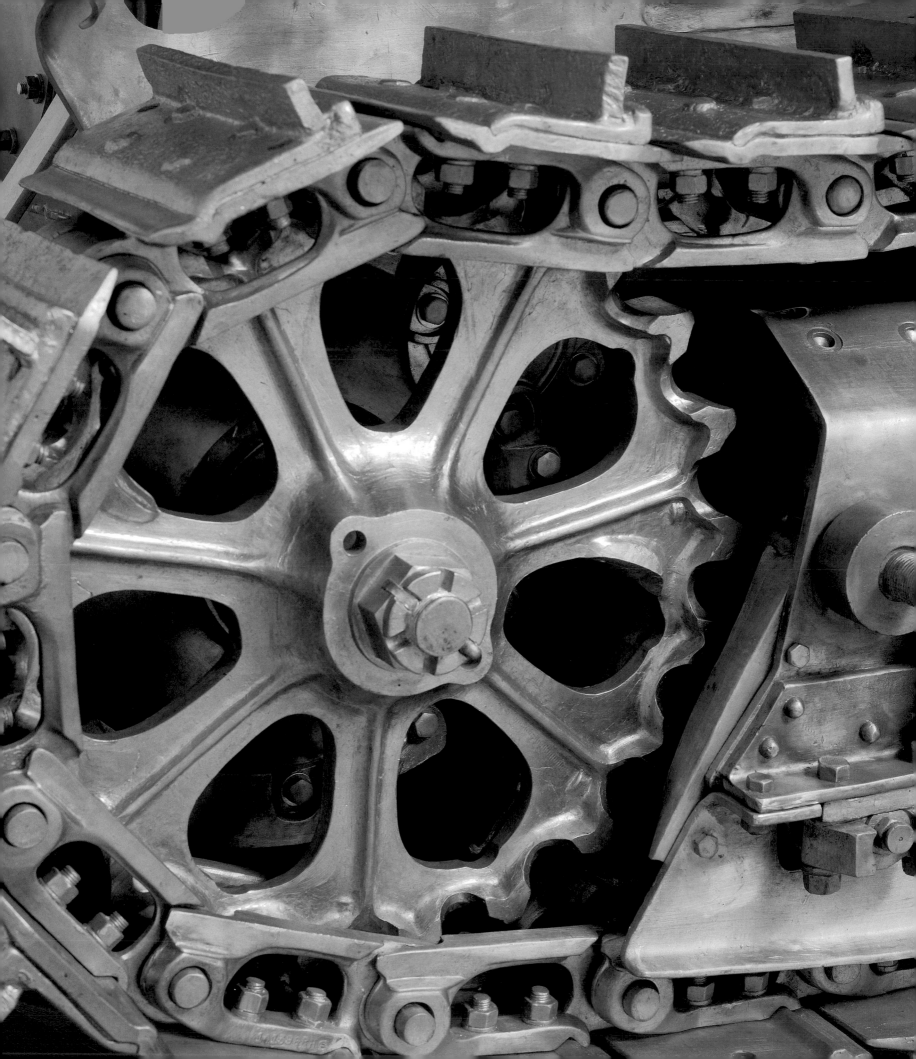

Ghost Studies

Jack Bankowsky

No Substitute, the third in a series of exhibitions presenting selections from the Glenstone collection and the first to focus exclusively on the museum's contemporary holdings, revisits the work of a generation of artists (or, better, three overlapping half generations) who came of age in the late 1970s and early 1980s. *No Substitute* begins where Conceptual and Minimal art—their by that moment well-worn protocols and procedures—were first found wanting by the rising art makers of the day. And it unfolds as a series of then-startling gambits, now all but synonymous with art as we know it.

Perhaps it goes without saying, but to my mind each truly significant artist to emerge since the mid-1970s has been energized by an impatience with one or both movements. Consider the words of Jeff Wall, speaking at the time of the first stirrings of his art in the 1960s: "We were—at some level—already examining ways of re-establishing a connection with pictorial art....We were not convinced by [Donald] Judd's polemics against European art and about internal relations in works of art."[1] Then recall the fulsome heresy of the elaborately composed, painting-size photographic tableaux that launched his career a decade later. Or picture Charles Ray's *Fall '91*, 1992. In the face of this sculptor's mature art, Judd's stacked boxes, as much as Dan Graham's interventions and instructions, suddenly looked like art history. Even Louise Lawler and Barbara Kruger, two artists in the exhibition whose work may seem relatively less rebellious with respect to their Conceptual precursors, are more perfectly appreciated in terms of their distance from the Idea Art that preceded them than by their proximity to its example.[2]

Charles Ray, *Fall '91*, 1992, Glenstone

A Photograph Is No Substitute for Anything. Photography was on the march by 1977. It was not just that the medium as traditionally understood was gaining on painting and sculpture, which for the first time were given a run for their money (and stature) from the fine and vintage print, but that a new wave of "photographers" whose ambitions had less to do with the discrete purview of the medium (the "photo ghetto") than with the "grand tradition" of art with a capital *A* was staking its claims in New York—and Vancouver! Both Wall and Cindy Sherman, this exhibition invites us to recall, first tested their game-changing innovations at precisely the same late-'70s moment. While the new rules would readmit, contra Minimalism and Conceptualism, the figure and narrative, the ambivalent nature of these "returns to representation" in the work of Kruger, Lawler, Richard Prince, and Sherrie Levine should be enough to suggest that the period rallying cry, for all its broad-strokes legitimacy, demands a measure of qualification. To begin with, the art most volubly associated with the return to the image in the latter '70s, neo-Expressionist painting, is nowhere to be found in these galleries. Indeed, in this selection of photographs but also, interestingly, a lot of sculpture (though not a single painting!), it is "photography"—more broadly, what photography did to art and what art, in turn, has done with photography—that hovers over the proceedings, whether the work at issue is a black-and-white print or, paradoxically enough, a two-ton aluminum tractor (no. 27). If photography, by dint of its capacity to instantaneously capture a likeness, backed painting and sculpture into the mitered corner of Minimalism (or so the story goes), it was also photography (albeit in this radically reinvented form) that would point art's way out of the neo-avant-garde cul-de-sac.

 No Substitute begins (conceptually if not according to floor plan) in a pair of rooms devoted to the work of five photographers, or, better, five artists, who make work with and about photography. Positioned midway through the show, the first of these galleries brings together two of Sherman's now-classic *Untitled Film Stills*, 1977–80, in which feminine archetypes conjured by Hollywood are enacted by the artist herself, with an early "rephotograph" by Richard Prince that lays bare the analogous ruses of the advertising image. The hilarity of Prince's lineup of found stereotypes, *Untitled (three women looking in the same direction)*, 1980 (no. 25), plays suggestively off Sherman's performed acquiescence to the confabulations of the male gaze as inscribed in the pulp outpourings of Hollywood, while Barbara Kruger's *Untitled (You Are Not Yourself)*, 1982 (no. 16), lends barking menace to the masquerade. Indeed, the sentiment offered up in the parenthetical subtitle to Kruger's signature graphic image/text hybrid could serve as a caption for the entire room.

 The adjacent gallery follows suggestively on this mass-media burlesque. Here Lawler's identical shots of Warhol's 1962 *Head of Marilyn Monroe*, titled, respectively, *Does Marilyn Monroe Make You Cry?* (no. 20) and *Does Andy Warhol Make You Cry?*, both 1988 (no. 19), share quarters with a pair of sculptures from Levine that overtly ventriloquize the art of the past. The first, *Fountain (After Marcel Duchamp): 1*, 1991 (no. 22), consists of a glistening reprise of the epochal readymade of 1917, and the second, *La Fortune (After Man Ray): AP1*, 1990 (no. 21), fastidiously re-creates as a sculpture the billiards table motif (uncannily at real billiards table scale) from the artist's painting

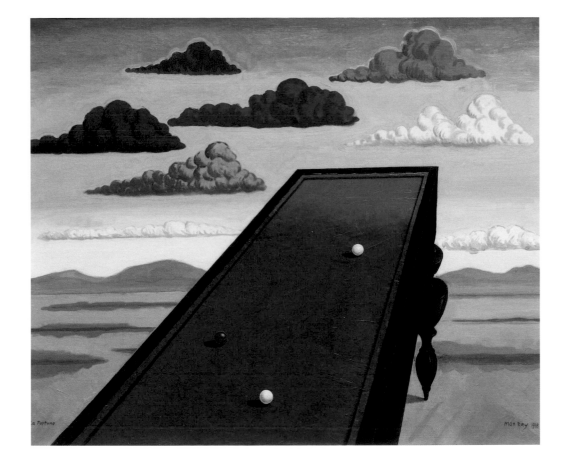

of 1938. Rounding out the proceedings is Lawler's sublimely deadpan *Pollock and Tureen, Arranged by Mr. & Mrs. Burton Tremaine, Connecticut*, 1984 (no. 18). Adding the American-style abstract master (and *Life* cover artist) to the lineup of big-time dads, the work's inclusion constitutes a wink on the part of Glenstone's founders, Emily and Mitchell Rales, to their own inevitable behind-the-scenes role in the canon skirmishes writ large in this room. The Tremaines, as careful lookers will note in the text of the wall label captured in the photograph, owned the gold Marilyn as well as the Pollock, and Glenstone, as it happens, now boasts Pollock's *Frieze*, 1953–55, as a highlight of its own postwar holdings.

 Duchamp, Man Ray, Pollock, Warhol: what is going on in this dance of girls and ghosts? To begin with, the curator is having some extra-credit fun with the coupling of Lawler and Levine, because like Duchamp and Man Ray, these artists collaborated early on in their careers, under the collective banner *A Picture Is No Substitute for Anything*. This explains the exhibition's title (and motivates my caprice in starting this overview in the middle), but it also points to the stakes—artistic and political—of this paternity pageant: Craig Owens, back in the day, read the title of their joint effort as coding "an unequivocal critique of representation as traditionally defined," citing as his placeholder for tradition art historian E. H. Gombrich's remark that "all art is image-making, and all image-making is the creation of substitutes," but he also teased out the urgency of this endeavor for these artists as women, which had to do with the masculinist bias of representation or, at the least, the image's less than neutral

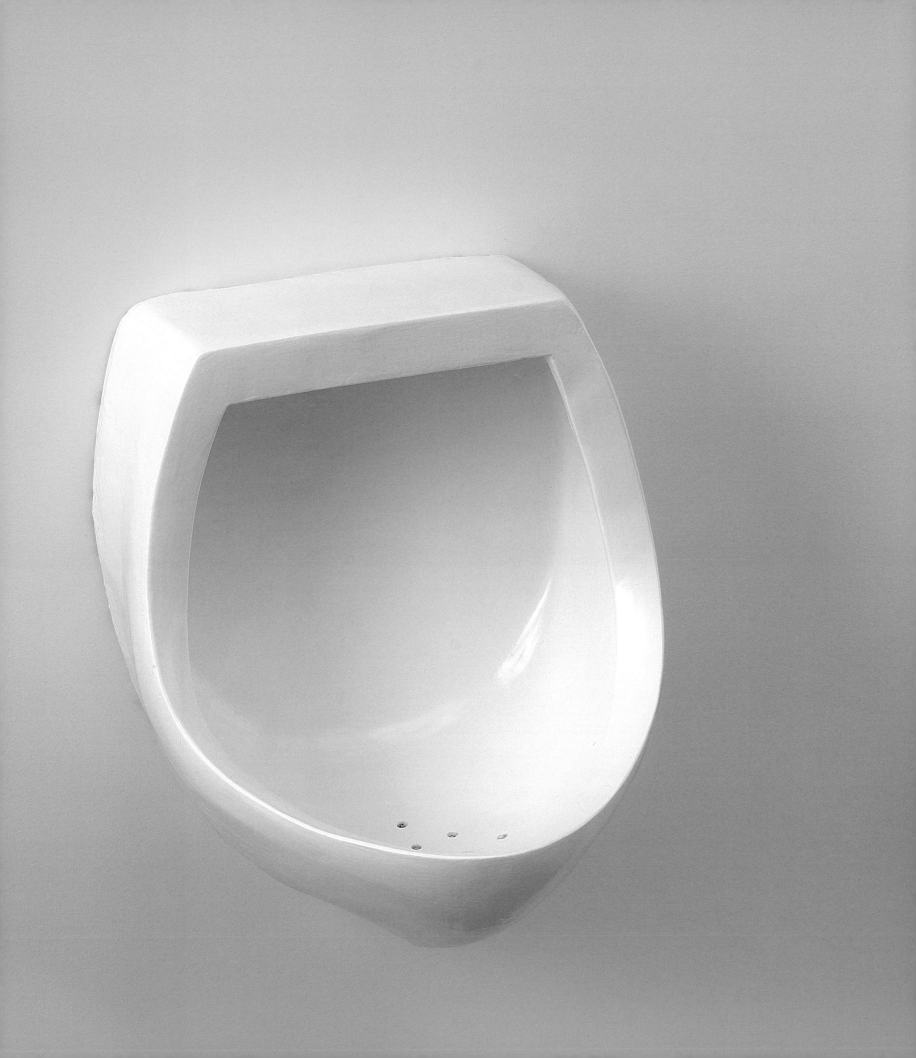

inscription in the regimes of power.[3] "Does not their collaboration move us to ask what the picture is supposedly a substitute for, what it replaces, what absence it conceals?" Owens continues, and indeed the artists assembled in this pair of rooms turn the image (and imaging generally) inside out.

The watchwords that orbited the "new photography" or "Pictures Generation," as the moment has come to be known, were, of course, *appropriation* and *simulation*—and we might add *sampling* to the list, if only to recapture the excitement of a phenomenon with ripples well beyond the art world. The way it worked in art (as much as in, say, drag or rap) had to do with a doubling that was also necessarily a difference, so that an artist like Levine would simultaneously do (as in mimic) and undo the masters she lifted from in much the manner that Sherman would challenge the guises served up to her as a woman by overperforming these prescriptions. Sometimes the shtick would be seamless: I still recall my giddy perplexity when I happened into a whole show of Walker Evans's famed *Let Us Now Praise Famous Men* photographs, indistinguishable from the real thing save for Levine's second signature. At other times she gave her routine a purposive twist. The bronze pissoir in *Fountain (After Marcel Duchamp):1*, for instance, is no longer a common, mass-produced utility: Levine has flipped Duchamp's gesture on its head by turning the urinal back into a precious art object—or, at any rate, made it plain that said recuperation was part of the subversive payoff of the original.

Taking the Piss. To treat as one the scarcely synonymous Minimalist and Conceptualist impulses and, further, to make this sketchy monolith a foil for the disparate range of subsequent art on offer here may seem a touch *voulu*. My point is that, by the middle '70s, there was a consensus of neo-avant-garde good taste that roughly accommodated the parameters of acceptable behavior encompassed by these movements, and it was against this new academy that virtually everything in this exhibition would thunder forth like the return of the repressed. Of course, the blind spots of this earlier art, what a given artist thought missing and yearned to see, varied from case to case—Robert Gober's Surrealistic plumbing and Jeff Wall's backlit history painting are no more identical than are Katharina Fritsch's Grimms for grown-ups and Thomas Demand's fact-or-fiction pictorial puzzles. Indeed, the beauty of the garrulous assembly of quoted voices in the pivotal reencounter of Levine and Lawler is that the curator has employed them to sneak into the proceedings a number of the precedents, or at the very least pressures, that would frame the view beyond the abstemious temperament of the Minimal and Conceptual past.

Duchamp and Warhol cast long shadows over *No Substitute*, as they do over the art of the latter half of the century more generally. Duchamp is predictably everywhere: not just in Levine's shiny readymade but in Gober's "handmade" iteration of the bathroom fixture that would never again be just a bathroom fixture. *Two Urinals*, 1986 (no. 10), rights Duchamp's upside-down fixture, which is to say, his urinals are no longer merely placeholders for that most common of mass-manufactured objects (a work of art because the artist says it is!) but rather (and specifically!) the public men's room fixture. One does not have to be Sigmund Freud—or gay—to identify

the moment before the urinal as an overdetermined one.[4] Indeed, when Gober made his first urinal in 1984, he thought it merely a "logical variation" on the sink motif, then the mainstay of his practice, but it finally felt too freighted ("1984," he recalled, "was the beginning of 'appropriation' and all people saw in the work was its reference to Duchamp"[5]), never mind the sexual and social baggage — Orwell, cruising, the darkening specter of AIDS. By the time he finished the pair of urinals exhibited here (the third of the five works based on the fixture that he would ultimately make), he had come to embrace the associations that he initially resisted. Another Duchamp — in this case the artist of *Étant donnés* — is felt in Jeff Wall's seminal *The Destroyed Room*, 1978 (no. 30), just as the master's luminous, hyperreal mirage is behind each of Wall's stylized, backlit tableaux. Indeed, in the catalogue accompanying *The Crooked Path*, the 2011 exhibition in Brussels devoted to Wall's influences and affinities, an image from the *Manual of Instruction for the Assembly of Étant donnés* (the photographs and notes Duchamp made concerning the work's original installation in his West Fourteenth Street apartment) is accorded pride of place. Even Rrose takes a bow at Glenstone, in the Prince/Sherman collaboration *Untitled (Richard Prince and Cindy Sherman)*, 1980 (no. 26), where the bewigged artists pose as each other (as Warhol?) in a period-perfect mash up of authorial prerogative.

Duchamp's influence is deep and abiding, and more to the point than a laundry list of overt allusions is, for instance, the ubiquitous pressure of the readymade on the way we view everything artistic these days. While there are no found objects proper in the exhibition with the sole exception of the gleaming grand pianos in Levine's *Newborns* (nos. 23–24), Fischli and Weiss's *The Objects for Glenstone*, 2010–11 (no. 3), an installation consisting of 398 entirely convincing trompe l'oeil replicas of various items mostly found in the art duo's Zurich studio, reminds us that this ongoing series (of which the Glenstone iteration is the largest to date) amounts to a profound, if oblique visitation (perhaps reversal is a better word) of the earlier artist's epochal procedure. Fischli and Weiss's accumulation duplicates the everyday clutter of a working space. It is precisely the nature of the individual objects they reproduce, to all appearances the most prosaic sort of real junk — here, an empty takeout pizza box or a tiny pair of foul-weather boots (left behind by a child of one of the artists?); there a roll of tape or a paint-spattered bucket — that, when revealed on closer inspection to be meticulously carved in polyurethane, occasions the reliably uncanny effect. Indeed I still remember the first time I happened on an early Fischli and Weiss accumulation at Sonnabend in New York and, convinced that the installation was still in progress, very nearly turned on my heels and walked away. Included among the clutter at Glenstone are a single gas nozzle (a nod to the patron's business) and a smattering of quintessentially American products — a Chips Ahoy! cookie box, a Milk-Bone carton — that, while readily absorbed in the clutter, might, for the hypervigilant, undercut the verisimilitude of this Swiss studio mise-en-scène. The gesture is the latter-day equivalent of the patron's visage showing up on a figure at the feet of the Madonna and Child, but with a couple of twists. The nozzle, it turns out, is a consumer object made not by the patron's business but by a competitor: "I liked the idea of giving him something he does not yet own," quips Peter Fischli, though it is also "just a great object."[6]

Marcel Duchamp, *Étant donnés: 1° la chute d'eau, 2° le gaz d'éclairage . . . (Given: 1. The Waterfall, 2. The Illuminating Gas . . .)*, 1946–66, exterior (top) and interior (bottom) views, Philadelphia Museum of Art

The first work in this sequence, *Das Floß* [The Raft], 1982, is not completely eye-foolingly verisimilar, but by *Raum unter der Treppe* [Room under the Stairs], 1993, at the Museum für Moderne Kunst in Frankfurt, the illusion was total. Here the artists took objects from a janitor's closet in the Frankfurt museum, copied them in polyurethane (the cheap, easily workable material used for Hollywood props), and then, as Fischli explains, "mix[ed] them up with copies of the tools used to make them and with sculptures that we've made long before."[7] It is really as if, David Weiss notes, "someone is busily working away there, but they've just popped out."[8] In a work like that at Glenstone, where the viewer is free to circulate among the accumulation, the temptation to touch and even pick up the objects is irresistible, and when one does, a tool apparently made of metal reveals itself to be as light as a paper cup. "They're a bit like will-o-the-wisps," Weiss explains, the objects visually but not quite physically there. They're "phantoms."[9] Recalling Wall's scrupulously art-directed urban *terrain vague*, the aesthetic surplus of Fischli and Weiss's work amounts to a kind of workbench picturesque, the fastidious duplication of the random accretion of human activity occasioning a sense of unmasterable serendipity. The artists, if you have glimpsed them installing such a work, are obsessed with the "look of chance," of man-made order where it gives itself up to chaos, or nature, or a higher order, and indeed they take amused pleasure in duplicating those inscrutable particulars, in moving the pieces around the board like divine chess masters — dressed in blue jeans.

Does Marcel Broodthaers Make You Cry? Warhol is the other titanic presence in the art of our period and inevitably in any show that attempts to come to terms with it. He makes himself known here in the pair of photographs by Lawler that preside over the central gallery, each picturing Marilyn Monroe, or rather Warhol's painting of the star-crossed star. In Lawler's images (taken as a pair, they are perhaps my favorite gesture in her oeuvre), the Pop master's modestly scaled gold tondo is captured in an auction house preview gallery, the customary wall label featuring provenance and presale estimate legible if barely so. Stenciled on the actual wall of the gallery just outside her framed photographs are a pair of questions-as-titles that are no less vital to the work than the image itself. Beside the first, Lawler recasts a cryptic pronouncement made by Marcel Broodthaers in 1968 to ask, "Does Andy Warhol Make You Cry?"[10] Beside the second, she poses a different but related question: "Does Marilyn Monroe Make You Cry?" In twinning these queries, Lawler reanimates Broodthaers's provocation, one that cuts to the quick of art's fate in the long aftermath of the modernist idea, but she also invites us to consider again art's relationship to our broader culture. Who is Andy? And who is Marilyn? And how does the former, the artist, if such a term still applies, get beneath the skin of the latter, the pure symptom of the star system? Are tears shed over Andy's "capitulation" to the culture industry today more then mere nostalgia for a bygone idea of what art can or ought to be? And what does the defensiveness of her precursor, understandably blindsided by Warhol's game-changing wager, tell us of the state of art making today?

Pop art, of course, provides one key to the Pandora's box of the Minimal and Conceptual repressed (the movement's return to the representational image in the aftermath of Abstract Expressionism, pointing back by implication to the Surrealism Clement Greenberg refused, is a connection that is not entirely irrelevant where, for instance, Gober's art is concerned). And yet while Pop's example, at least in Warhol's iteration, may be implicit in these galleries, it is more as a pressure and foil than as an enabling paradigm, save for one (or, at most, two) cases. Damien Hirst, represented by a signature medicine chest titled *Is Nothing Sacred*, 1997 (no. 15), is the outlier here both generationally and because he seems to take up Warhol's challenge directly. Installed in the reception area, which is to say just outside the show proper, his work serves as a kind of knowing "yes, but…" on the part of the curator where the Pop lineage is concerned, a nod to another strong current in contemporary art but not the one in focus here.[11]

Sleeping Dogs. If the artists in this show can be said to share one thing, it must be the desire to engage, once again, with the seductive power of the image, whether those seductions are formal or art historical (Wall and Ray), mass mediated (Kruger), or folkloric (Katharina Fritsch). One can — and this is true for myself — remain altogether alive to Minimalism's ground-clearing vigor, even as one surmises that the historically specific power of those anxious objects is destined to pale somewhat in the larger narrative of art. Minimalism's definitiveness, its narrowness, was also its potency, and while it opened a previously unimagined microcosm of sculptural possibility on the cliff's edge of anti-sculptural theatricality, it also swept away just about everything else that art was meant to be and do in the process, and this "everything else," or at least selective parts of it, is where the artists of the next generations would turn.

Take Gober again, an artist for whom the common (or should I say archetypal?) kitchen-sink drain is a portal to the undercurrents of the unconscious, the everyday street-side storm drain a window not on to mashed leaves but Jacques Cousteau magic (and — so much for setting aside the modern life imagery of Pop — a smashed Budweiser can). Indeed Gober's sinks, of which three are exhibited here, all but literalize my Minimal repressed; they can look a bit like Minimal sculptures, to be sure (at least ones pulled back from the assembly line suggested by that earlier art's hard edges and mechanical facture, then gently retouched all over), until we recall that they are not just planes and perforations but versions of bathroom fixtures, if somewhat hallucinatory ones. A work from one of my favorite series by the artist, *Untitled*, 1987 (no. 11), takes that coziest of domestic comfort objects, the doggy sleeping basket, and gives it a creepy twist. Gober has printed the flannel cushion fabric with the most improbable pattern, a hunter taking aim with his rifle, alternated with images of the head of a live buck and a recumbent, presumably dead one with a rifle draped across the carcass. One year later, in 1988, the pillow would appear again, but covered in a new pattern, this time alternating an image of a white man peaceably slumbering with one of a black man lynched from a tree, as if to suggest a chilling thought bubble wherein the former dreams the latter. It does not a rocket scientist take to point out that Minimal sculptures do not, as a rule, come covered in *toile de NRA* or that, in the later work,

this basket of strange fruit is a far cry from a didactic examination of the racist undercurrents in our society. Gober's art does its work in another register, which I would be tempted to call poetic if that cop-out did not come so cheap. Suffice it to say that this art is as decidedly remote from mere "information" as from "pure form," though to discount it, with Michael Fried, for its surreal "taint" is to miss the deliberateness of facture that lends Gober's strongest objects (the sinks on view here are a good example) a slow-boil gravitas that belies the illustrativeness that made the Surrealist impulse constitutionally trivial to old-school formalists.[12] The power of Gober's objects comes from their visual acuity and material scrupulousness—the woven (not found) wicker basket, the hand-painted flannel—and, just as important, the compression of meaning, however ambivalent, that such precision allows, as much as from their ostensible "content." Gober's homespun plumbs the gothic subtext that American-style abstract art, the tradition that Minimalism would crown and crash, had left undisturbed, but (and here my straw-man antithesis reveals its shabby stuffing) it retains a "sculptural" presence that affirms his debt to this lineage as pointedly as he revisions it.

Between the Church and the Shopwindow. The legacy of Minimalism may be less a signpost for a European artist like Katharina Fritsch than for her American counterparts, and indeed when asked about the "return to figuration" of the 1980s, she maintains that her reaction to the abstract status quo was more circumstantial than calculated, though she recalls that the dominance of Minimalism in the '70s added to the surprise and force of her early initiatives.[13] Fritsch's "return to the figure" shares with Gober's both a relationship to the readymade and his Surrealist bent; indeed she acknowledges Surrealism as an important influence, though, as she has explained, "I have gone a stage beyond it towards reality."[14] By this she means that she has not only turned her oneiric visions into physical objects one can walk around and touch (not that one should do the latter, of course!), but that she has achieved a material intensity that has allowed her to skirt the illustrative or anecdotal sand trap that made the historical movement a Greenbergian bugbear. Fritsch has said that she is after a reality "more real than real," and it is the precision with which she manages the physical particulars of her art—her use of scale, her stylization and blurring of figural details, her employ of typically monochrome color as a unifying or estranging device—that enables the magic.[15] While her "sculptures" may have more to do with the image, with the overall visual gestalt, than with strictly spatial relationships (Ray's art, to be sure, is more "sculptural," more "medium specific"), my larger point is that neither artist is after all trafficking in I beams or Cor-Ten slabs.[16] If we are to get anywhere with either of them, we will have to find a way to move from form and facture to—one struggles for a better word—"content," and then, just as crucially, back again.

Rounding the corner from the Gober galleries, one encounters a trio of life-size figures: *Mönch* [Monk], 1997–99 (no. 4), a matte black effigy of what Fritsch drily calls—it is always drily with Fritsch—an "unholy holy"; *Doktor* [Doctor], 1997–99 (no. 5), a stark white skull and bones in a physician's smock that the artist must have had to restrain herself from titling Dr. Death; and *Händler* [Dealer], 2001 (no. 6), a double-breasted purveyor of beauty and truth realized in a red so red it out-Kleins Klein

blue—with, ouch, a cloven hoof.[17] I say "ouch" because Fritsch routinely walks a fine line between cliché and archetype, a tricky poise that in fact cuts to the quick of her art. Take her early *Madonnenfigur* [Madonna Figure], 1987: Here, famously, the Virgin Mary (or rather, a traffic-warning yellow blowup of a souvenir Madonna), shows up on a Münster plaza halfway between a church and a shopping strip. No shroud-of-Turin vagary to this siting; thanks to the uncanny enlargement (to human scale) and its radiant yellow hum, the kitschy keepsake appears as a full-bodied Technicolor miracle! A similarly simple alchemy is afoot in *Gespenst und Blutlache* [Ghost and Pool of Blood] from the following year. This time the apparition takes the form of a Halloween-costume cliché, a body covered in a bedsheet. Meticulously crafted in her signature polyester, each fold a marvel of intentionality, the result is as spooky (if improbably so) as a ghost would undoubtedly be—if we had ever seen one! Fritsch is interested in the ways we parse the world and make it knowable to ourselves, in, above all, our fairy tales and figments, and she savors that split second when our perceptions suddenly shift, when, say, one's eyes cross and the benign-looking gentleman reading the paper over his half glasses at the corner café is also a war criminal. I experienced a like shudder when I turned the corner at Glenstone and found myself face-to-face with her lineup of ur-monsters. Anyone who has ever heard Fritsch ruminate about mankind (or men specifically!) can well imagine her jaundiced eye alighting on a (humble?) servant of god and imagining instead a celebrant of the dark arts so black the sun itself might vanish into the folds of his cassock. And as for the avant-garde dealer— a groomed ponytail this false shepherd's last vestige of countercultural credibility— the hoof says it all. In each case the well-observed nuance meets up with a fairy-tale

1987 installation of
Katharina Fritsch,
Madonnenfigur [Madonna
Figure], 1982, Münster

46

flourish, in a crystalline, made-for-television…sculpture. "Double Life" is Fritsch's term for this oscillation between the sacred and the profane, between kitsch cliché and resounding symbol, and I am next to certain Jeff Koons knows what she means.[18] Blink once and her Madonna is the mother of god; blink twice and she's, well, Madonna.

The Tractor in the Room. No artist, in the outward aspects of his mature practice, has further separated himself from his Minimal and Conceptual precursors than Charles Ray, and, at the same time, none has taken greater pains to align himself with the larger sequence in American abstract sculpture that those twin movements would at once cap and decommission. Ray's continued (and to some minds counterintuitive) insistence on high formalist sculptor Anthony Caro as his key progenitor already constitutes a swerve away from more probable Minimalist and Conceptualist prece-dents[19]—but the real originality of Ray's creation myth lies in his emphasis on this broader abstract pedigree even as he has reached for the forbidden fruit of the figure. The mystery of his art, indeed, resides in the fact that this baby step backward would allow him to mine the riches of the entire pre-abstract sculptural past (including the deep past of antiquity), though the converse might equally be argued: in dipping into the historically distant, Ray has retrieved for the present a more capacious and abiding meaning for abstraction.

Untitled (Tractor), 2003–2005 (no. 27), the sculpture that represents Ray in this exhibition, is as good an example as any when it comes to marking the convergence of a recognizable image and his insistently abstract concerns. A tractor, it goes without saying, is a good deal more "literary," less a neutral prop for formal investigation, than a beam of steel. Tractor, like Ray's work more generally, is "sculptural" before it is any-thing else, space and form its first language, but it is also a piece of farm equipment or, in any event, a representation of one. An industrial object—or rather archetype—it is a bit, even, like a Turner train emerging with the steam dream of a new day, save for the fact that by now, well into the age of information, Ray's "machine" speaks of the modern past as much as the future. Based on a memory of a derelict tractor he scrambled over as a child at play, the vehicle he took as his model had lain idle for some forty years by the time he rescued it, and the artwork that resulted pushes before it some of the melancholy of the ruin, a trope of transition, both temporal and material, in fundamental ways bound up with the long take this sculpture demands.

Tractor was the first piece of Ray's I experienced during its (protracted!) realiza-tion, and throughout the process he worried the relationship of the part to the whole, and of the whole to the room, and of both to himself as a stand-in for the viewer. He famously had each component of the machine molded in clay by a corps of assistants, then cast in aluminum and reassembled, allowing the variousness of their hands to enter the work even as he second-guessed the serendipity this procedure admitted. Assistants are a bit like dreams; their idiosyncrasies and accidents can allow an artist to see beyond his or her own waking rules, and Ray was happy to put the dreamwork to work, though he was surprised to learn when Tractor was finally assembled how quickly the overall gestalt quieted the cacophony of disparate touches. Quickly, but not entirely—and this "not entirely" manifests itself in the work's slight lumpishness,

in a certain simmering deliberateness that, despite its metallic unity, suggests that the sculpture has been literally massaged into existence. For all its production labors, *Untitled (Tractor)* is hardly a "machined" instrument, a fact that creeps up on the viewer as one surfs its cavities and crannies (his crew molded and cast even the interior parts of the tractor, including those that would remain inaccessible to view).

Tractor carries — it is finally inevitable — something of the American heartland and dream in its deepest chemistry, yet Ray's subject is no more farming than pure form but rather representation as such, a problem set that unfolds as this at first glance rather dire mass of metal, gradually, tenderly, enlivens both the space within its bulk and the air surrounding it. It's this ineffable balance, between the overall gestalt and the fully touched and "represented," between the elephant in the room (a tractor!) and the art it here becomes, that must have inspired the artist when he remarked of the sculpture: "I would like to rename it *Philosophical Object*."[20]

Substance in Style. The event of a significant artist clearing space for him- or herself in the busy narrative of culture tends, in retrospect, to look like a fait accompli, while in reality it is always something of a miracle. Wall, who emerged at the end of the '70s from a prolonged period of searching indecision with an art that seemed not just fully formed but also unimaginable by the standards of his immediate forebears, is as vivid an example as one will encounter.

Wall is, in a sense, the neatest test case with respect to my Minimalist and Conceptualist double foil in that he has grappled, more or less explicitly, not just with one precursor movement but with both. In the recent self-curated Brussels show devoted to his own artistic pedigree,[21] Wall nods both to Conceptualism (for instance, to his onetime collaborator Dan Graham) and, more willfully (he is, after all, a photographer and maker of images!), to Carl Andre, represented by a classic floor grid. Wall, of course, slew both these dads long ago (indeed his wager, in living up to their yin-yang examples, was paradoxically to reinvigorate the traditional compositional and pictorial possibilities associated with painting that their art had, in different ways, forsworn). Yet it was precisely the pressure of this double legacy — the scale of Minimalism; Conceptualism's wariness of artistic convention — that allowed him to imagine the future by returning to the past, and this without degenerating into pastiche or revivalism.

As a young artist, Wall was fully engaged with the experiments of the '60s and '70s (he admired the work of Graham, Robert Smithson, and Ed Ruscha) but never in a way that he found entirely satisfying. By the end of the '70s, the whole extended neo-avant-garde moment, and the attendant notion that art must effect a break with the past, must negate or at least redefine what came before it, seemed to him a blinkered approach to art's engagement with itself and with the world.[22] It was the hard-won courage of this acknowledgment that would allow him to return to the photographic canon, to Evans and Eugène Atget, but also to Robert Frank, and Weegee, and, Stephen Shore, and Garry Winogrand — in short, to the whole tradition of "straight" photography that, until this moment, had felt foreclosed to him — and, by extension, to his great and abiding love, the depictive tradition associated with

figurative painting. Where Wall found his window of opportunity, the fissure wherein he would fashion himself as "A Painter of Modern Life" (in, ironically, the medium of photography!), would involve precisely a fusing of the scale and artifice associated with nineteenth-century painting and the documentary quality synonymous with the younger medium of photography. It was photography, indeed, that supplied the contemporaneity Wall understood as essential to Baudelaire's celebrated conceit. At the same time, his chosen support—transparent colored film mounted on metal light boxes—had, to his mind, as much to do with the "literalism" in time and space associated with the Minimalist object, with a "physical presence" he believed requisite to his pictures if they were to hold their own in the tradition (and the moment), as it did with the seductive glow of the advertising marquee.[23] That *The Destroyed Room*, 1978 (no. 30), the work that announced Wall's mature style, was first exhibited in the storefront of a Vancouver gallery where the image's availability to the unsuspecting passerby, not to mention its writ-large relationship to the thematic of the shop-window, was the loop in the knot of presentational and other thematic concerns that signaled the sweep of his ambition.[24]

 When Wall recently remarked that the "gray area between inflection, or 'causing' and 'not causing,' is where photography really lives," he was referring to the space between photography understood as a direct impress of reality (and thus as reportage) and, alternately, as "cinematography," the term he adopted to describe the highly contrived manner exemplified in *The Destroyed Room*.[25] The "cinematographic" or "collaborative" range of the spectrum, as Wall is quick to point out, in fact runs the gamut from the most modest intervention (a photographer, for instance, asks a subject to hold still while he snaps the picture) to the wholly constructed tableau, and Wall has never confined himself to one end of the scale or the other but has worked the gradations in between. The three pictures at Glenstone range from, on one extreme, the stage-set-like *The Destroyed Room*—a picture of a catastrophe in the life of, we gather, a woman, famously alluding to Delacroix's *Death of Sardanapalus*, 1827—to *Rear view, open-air theatre, Vancouver*, 2005 (no. 32), an image of a perfectly quotidian back-alley parking lot that, for all intents and purposes, could be a single-take snapshot. The final of these three images, *An Eviction*, 1988/2004 (no. 31), falls someplace in between. The only picture in the group that features the human figure (the image shows a tussle between two police officers and, we surmise from the title, an about-to-be-dispossessed homeowner), the work could easily represent an observed scene (or be based on one, as many of Wall's images are), a fact enforced by the everyday if downscale suburban setting. Owing to the fact that the camera is pulled back from the putative action, the peripheral sprawl—it embodies just the sort of uncanny reality effect the art-aware passerby has in mind when dubbing some particular location "very Jeff Wall"—is as much the subject of this picture as the ruckus itself. What first tips us off that the scene was not simply chanced upon and captured in the instant is, I suppose, the postures of the figures, especially the woman rushing to the defense of the embattled protagonist, her arms outstretched in high-mannerist extremis. Wall has said he wants the "design of a Matisse but with the reportage quality bonded to it,"[26] and, indeed the tension between the patently pictorial and

the apparently circumstantial, between form and document, is as palpable within the individual works on view at Glenstone as between them. It is telling in this respect that, when asked by the Musée d'Orsay to exhibit one of his own photographs next to relevant objects from its collection, Wall positioned *Rear view* alongside several images by Atget, a favorite photographer whose subject was of course a Paris vanishing into modernity, and a single Cézanne, a painter so surgically obsessed with the deep structure of pictorial visuality that Wall, in this context, joked, "If Paris disappeared he would barely have noticed."[27]

The New Grotto. If you asked me to name the subject of *An Eviction*, I would be as tempted to say a large, somewhat ill-pruned bush on a parched meridian (with a fracas in the background!) as the homeowner's struggle of the title, if only to underscore the fact that Wall's relationship to such anecdotal particulars, however extreme they may be, has always been more aesthetic than instrumental (Wall is, he professes, a fan of Kant!). This is not to suggest that the philosophical tenor of his art fails to sensitize us to the sometimes harsh world we live in but rather to insist, as Wall himself has done, that his art, motivated by what he has called quite nakedly a "love of existence," takes as its "subject" the world in all its variousness — and existential oddness — not to mention the scarcely divisible problem of how we represent it to ourselves. The sentiment, if we are to lift it above maudlin generality, can be seen both to connect and to distance his work from the photographic zeitgeist of the latter 1970s and its legacy with respect to subsequent art making.

In the context of *No Substitute*, Thomas Demand is, like Hirst, something of a generational footnote, yet his engagement with the problem of depiction as such aligns him with the exhibition's main current. He emerged on the scene a decade after Wall and his Pictures Generation peers, following as well the rise of the "new" German photographers — Thomas Struth, Thomas Ruff, and Andreas Gursky — who by the end of the '70s were already at work (if not yet exhibiting). And yet, as a photographer who fabricates his subjects as fully articulated objects before he ever shoots them, Demand can be understood not only to have amplified the lessons of his photographic precursors on both sides of the ocean but to have absorbed the sculptural example of, for instance, Fritsch, whose influence was unavoidable at the Düsseldorf academy where he studied, as well as, implicitly, those of Fischli and Weiss, Ray, and perhaps even Gober.

For Demand, the "irony of the simple, mass produced object being hand made" was already a worn idea by the time he entered the discussion, and yet the power of this basic move undergirds his art, albeit in an expanded sense. *Leuchtkasten* [Light Box], 2004 (no. 1), the first of two pieces on view here, consists of a head-on shot of an image-less light box that cannot but be taken as a pointed wink to Wall and the historically specific nature of his signature support.[28] Demand came to the idea of making this work when, groping for a way to represent Germany in the São Paulo Biennial, he noticed a once-radiant shell hanging empty on the side of a building near the exposition grounds. Inspired by the exposed interior — the neon bulbs, the cables and colors ("how weird they all looked")[29] — he took a picture of it. Then, he meticulously built a

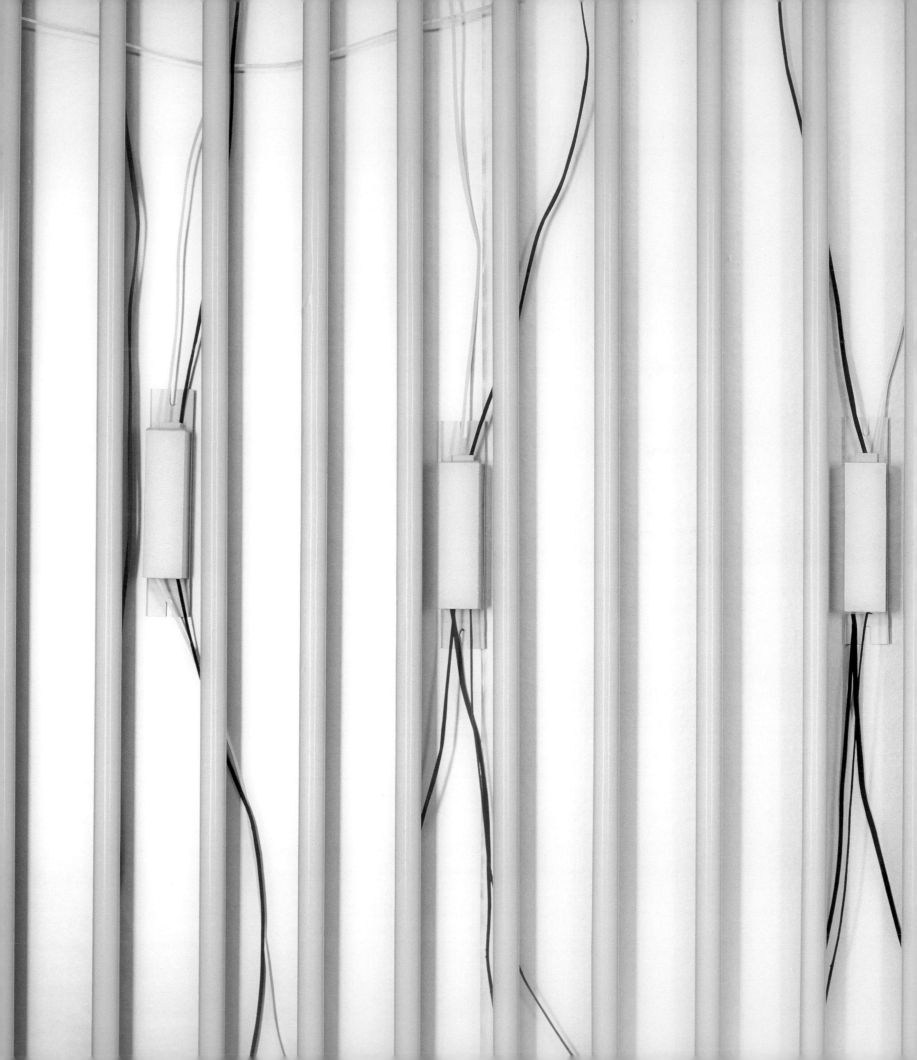

replica in paper at nearly the exact size (Demand's models are always close to one-to-one scale), photographed his model with a large-format camera, and, finally—the poignant punch line!—discarded the delicate handwrought confection, so that the photograph remained its only trace. "Make-work"—by which I mean labor that is extraordinary and even seemingly redundant—is a powerful trope in art in the age of post-photography, and it has everything to do with the uncanny power of an image by Demand or an object by Fischli and Weiss. Wall, for instance, will remake at great expense of time and labor a perfectly unremarkable room, and, as much as he downplays the importance of such behind-the-scenes information, the mystique of this symbolic expenditure haunts his art. Close looking will typically provide a hint that some such artifice is at work in a photograph by Wall. In fact, in the illusions of all of these artists there is typically something discernibly "off"—in Demand's case often not so subtly so, though the fact that we, for at least a moment, experience his pictures as what they pretend to be (in this case, a real picture of an empty light box!) is as key to the dis-ease they engender as the fact that (at the risk of exposing myself as a hapless victim of my own game) Ray's sculpture of a tractor is a *sculpture* of a tractor!

I am tempted, on the one hand, to distance Wall's photographs from those of Demand—or, for that matter, the early bolt-from-the-blue efforts of Levine or Prince—because Wall's particular negotiation of manner and reportage seems uniquely to slip the noose of the photography-about-photography endgame synonymous with this period, and yet Demand's engrossing Chinese-box conundrums demonstrate their own affective range. To reveal that a photograph is a fiction is to reveal next to nothing at all; if the camera is a fiction machine, that is because, as Demand has suggested, the brain is one, too, because "every memory is a reconstruction," a sentiment not un-related to Levine's meaning when she remarked that her subject was "representation as such."[30] If, as Wall has suggested, the space that opens between impress and artifice, between document and fabrication, is constitutional of the photographic medium as such, then the glue that connects a photograph of a photograph of that most famous of Madison Avenue fictions, the Marlboro Man, and Demand's shimmering arche-type of romantic nature (a grotto in Majorca that he would never visit save in the form of an antique postcard) is the fact that each work catches the photograph in the act—which is to say, captures the wonder and oddness of our world-making in the making. The differences between these practices—the differences that account for their appreciable art—involve the specificity of the way each sets its traps. In the case of Demand's *Grotto*, 2006 (no. 2), the final work in the show (and one of the marvels of the modern world of picture making), that "difference" depends on three tons of cardboard, an artistic intelligence capable of making the necessary discriminations—"too Harry Potter" or "too ice cave"[31]—and a truth to the present that would not refuse the digital, but found, ironically, that the best way to accommodate it was by building each pixel needed to achieve the effect he desired by hand, by turning a two-dimensional picture postcard into a three-dimensional room-size sculpture, and then back again.

1. Jeff Wall, "Vancouver in the 1960s and 1970s," interview by Hans De Wolf, in *Jeff Wall: The Crooked Path*, ed. Hans De Wolf (Brussels: BOZAR Books, 2011), 27.

2. While Kruger's violation of the image with text obviously aligns her art with that of earlier Conceptualists, her allegiance to the sound bite and the formidable feat of graphic branding that put her on the map eschew the expository utility of the Conceptual photograph. Her work is motivated instead by an instinct to meet the gaze of the mass media on its own terms, to get under the skin of our image culture and turn Madison Avenue's gambits on themselves. Similarly Lawler's "critical" look at the art object's special commodity status and the institutions that underwrite it implies a delicate pact with the collecting class. Indeed, her infiltrations of the salons and showrooms where art and power collide and collude suggest an almost performative dimension to her art of witness that sets her apart from "the moral purity and retinal austerity" (to borrow Wall's words) of her Conceptual forebears. The distance of Kruger and Lawler from this earlier art may seem relatively modest, but, to my mind, it is defining with respect to their generational relevance.

3. Craig Owens, "The Discourse of Others: Feminists and Postmodernism," in *Postmodern Culture*, ed. Hal Foster (London: Pluto Press, 1985), 73.

4. Hal Foster has played the moment before the urinal and the prosaic connotations of Gober's return to this readymade to amusing effect. See Hal Foster, "The Art of the Missing Part," in *Robert Gober*, ed. Paul Schimmel (Los Angeles: Museum of Contemporary Art, 1997), 63–64.

5. Theodora Vischer, ed. *Robert Gober: Sculptures and Installations 1979–2007* (Göttingen, Germany: Steidl, 2007), 70.

6. Peter Fischli, in conversation with the author, Zurich, October 16, 2011.

7. Peter Fischli and David Weiss, "Between Spectacular and Ordinary," interview by Claire Bishop and Mark Godfrey, *FlashArt*, November–December 2006, http://www.flashartonline.com/interno.php?pagina=articolo_det&id_art=29&det=ok&title=PETER-FISCHLI-AND-DAVID-WEISS.

8. Peter Fischli and David Weiss, "The Odd Couple," interview by Jörg Heiser in *Frieze*, October 2006, http://www.frieze.com/issue/article/the_odd_couple/.

9. Fischli and Weiss, "The Odd Couple."

10. "And another word for those who have not participated in these days [of occupation of the Palais des Beaux-Arts] and who have despised them: you don't have to feel that you sold out before having been bought, or hardly. My friends, I cry with you for Andy Warhol." Broodthaers's "open letter" was written three days after Valerie Solanis's attempt on Warhol's life and on the heels of the May 1968 occupation of the Palais des Beaux-Arts in Brussels, where the Belgian artist founded his factitious *Le musée d'art moderne*, but was nevertheless dated June 7, 1968. Broodthaers would offer a corrective in his second open letter, written later that month: "In my letter of June 7, '68, it should not read: 'You don't have to feel that you sold out before having been bought.' Rather, it should read: 'You don't have to feel that you sold out after having been bought.' This is only to content everybody's ass and everybody's father. My friends, who is Warhol?" See Benjamin H. D. Buchloh, "Open Letters, Industrial Poems," *October* 42 (Fall 1987), 83–84.

11. Richard Prince is the other artist in the show whose work in general and later output in particular owes a direct debt to Warhol's example, which is already signaled in his bewigged portrait with Sherman that shares the lobby annex with Hirst.

12. See Michael Fried, *Four Honest Outlaws: Sala, Ray, Marioni, Gordon* (New Haven, CT: Yale University Press, 2011), 87.

13. Katharina Fritsch, "Thinking in Pictures," interview by Susanne Bieber, in *Katharina Fritsch*, ed. Iwona Blazwick (New York: Matthew Marks Gallery, 2002), 97.

14. Fritsch, "Thinking in Pictures," 98.

15. Katharina Fritsch, Glenstone archival interview by Emily Wei Rales, Potomac, MD, May 9, 2011.

16. Both Ray and Fritsch, it seems to me, are quite self-consciously aware of their place along this syntactical spectrum, an intuition borne out by the fact that the former makes reliefs—sculptural pictures—and the latter "paintings" that serve as backdrops for her objects.

17. Fritsch, Glenstone archival interview by Emily Wei Rales, Potomac, MD, May 9, 2011.

18. Ibid.

19. Ray's interest in Caro came through his teacher Roland Brenner and in this sense was entirely organic, preceding both his early phenomenological investigations and his performative experiments that spoke to sculpture's primal moment as a stand-in for the human body (the affinities here are Robert Morris, Chris Burden, and Bruce Nauman), and yet, within this expanded field of endeavor, the continued invocation of Caro (e.g., on the cover of the catalogue accompanying Ray's 1998 Museum of Contemporary Art, Los Angeles, retrospective) is surprising—and altogether pointed—given the course his work had taken.

20. Charles Ray, *Charles Ray* (New York: Matthew Marks Gallery, 2009), 30.

21. For the exhibition *The Crooked Path*, held at BOZAR in Brussels from May 27 to September 11, 2011, before traveling to the Centro Galego de Arte Contemporánea in Santiago de Compostela, Spain, Wall placed twenty-five of his own pictures in the context of some one hundred and thirty works by artists he has identified as contributing to his development over the preceding four decades.

22. Jeff Wall, Glenstone archival interview by Anne Reeve, New York, NY, September 21, 2009.

23. Jeff Wall, "Frames of Reference," *Artforum*, September 2003, 191.

24. Thomas Crow has eloquently addressed the connections between Wall's presentational and thematic concerns: "But like all temporary, site-specific pieces, this installation is as significant for the permanent idea it implanted as it is for the impression it may or may not have made on its limited original audience. This was the residue of grand historical painting as presented to and transformed by the vision of the random urban pedestrian. Delacroix rather than Manet had after all been Baudelaire's idea of the consummate artist: *The Destroyed Room* is Delacroix under the gaze of the flâneur and his low-life surrogates—the prostitute, street criminal, and derelict rag picker—for each of whom the violent tableau would have distinctly different meanings." (Crow, "Profane Illuminations: Social History and the Art of Jeff Wall," *Artforum*, February 1993, 65.)

25. Jeff Wall, Glenstone archival interview by Anne Reeve, New York, NY, September 21, 2009.

26. Ibid.

27. Ibid.

28. Wall has foregrounded this factor himself, of course, in turning to straight prints and gradually duplicating his oeuvre in non-illuminated versions.

29. Thomas Demand, Glenstone archival interview by Anne Reeve, Potomac, MD, March 1, 2010.

30. Gerald Marzorati, "Art in the (Re)Making," *ArtNews*, May 1986, https://www.msu.edu/course/ha/452/artinmaking.htm.

31. Sarah Crompton, "Gained in Translation," *The Telegraph* (London), May 27, 2006, http://www.telegraph.co.uk/culture/art/3652663/Gained-in-translation.html.

Plates

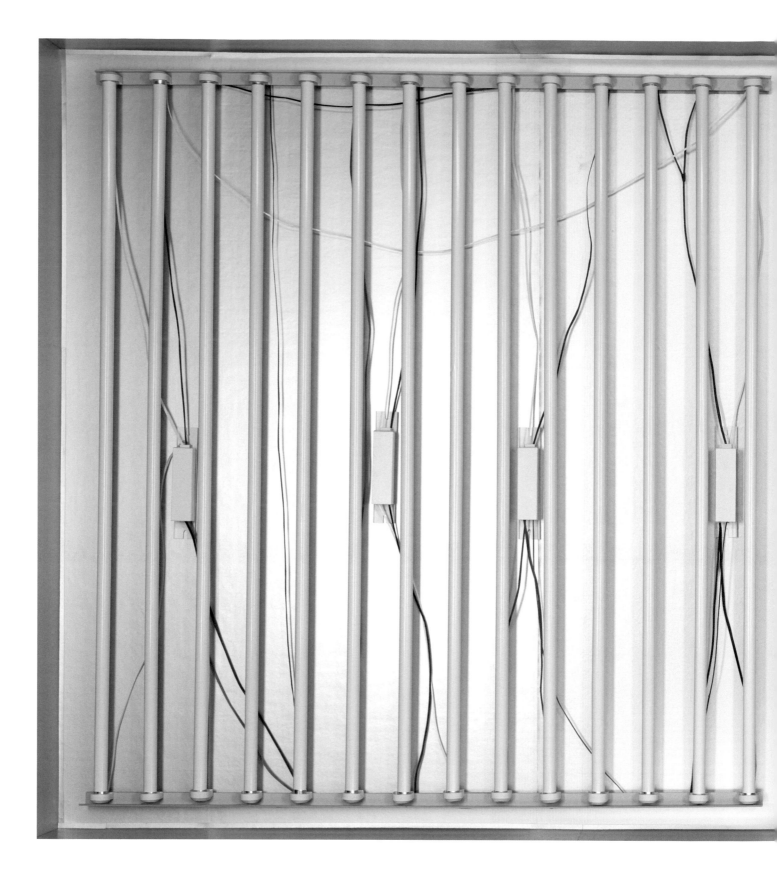

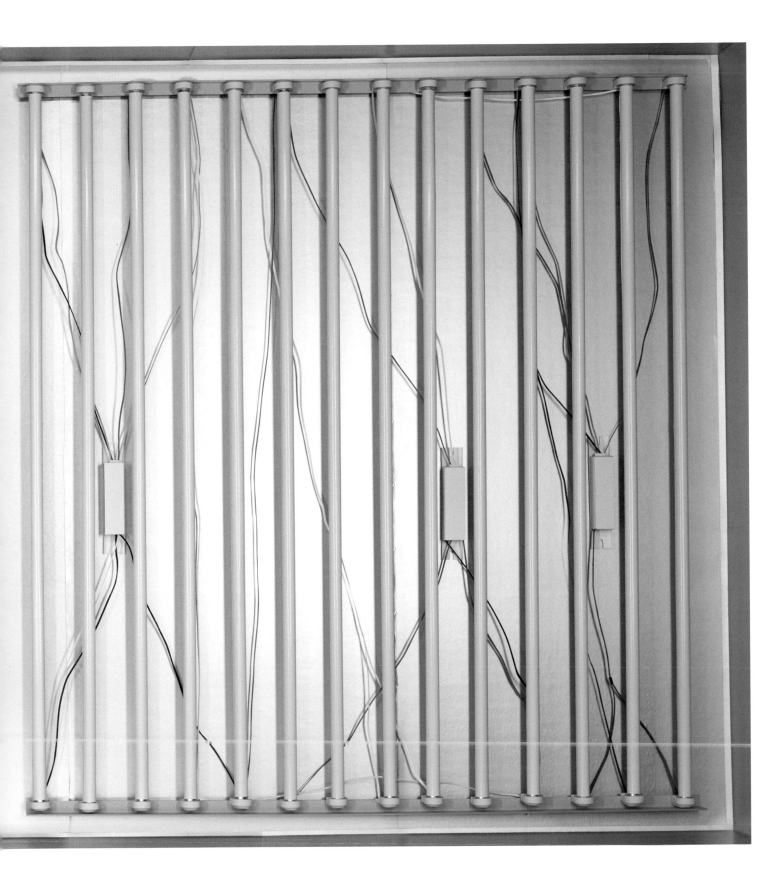

1
—
Thomas Demand
Leuchtkasten [Light Box]
2004
C-print mounted
on Plexiglas

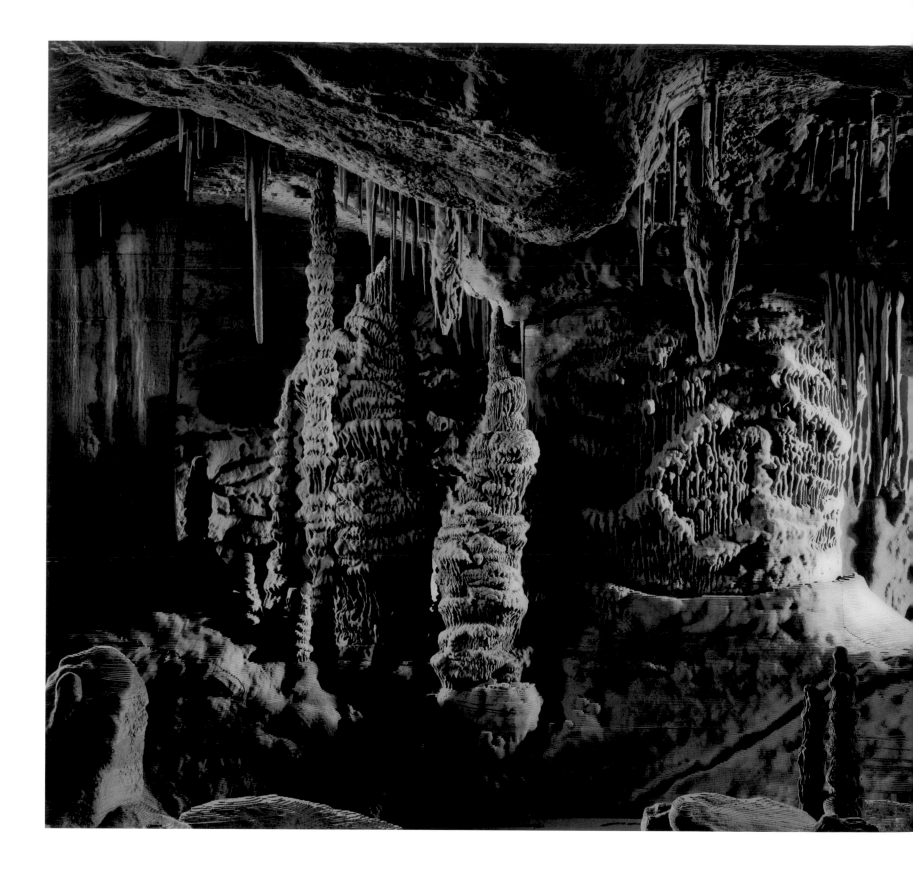

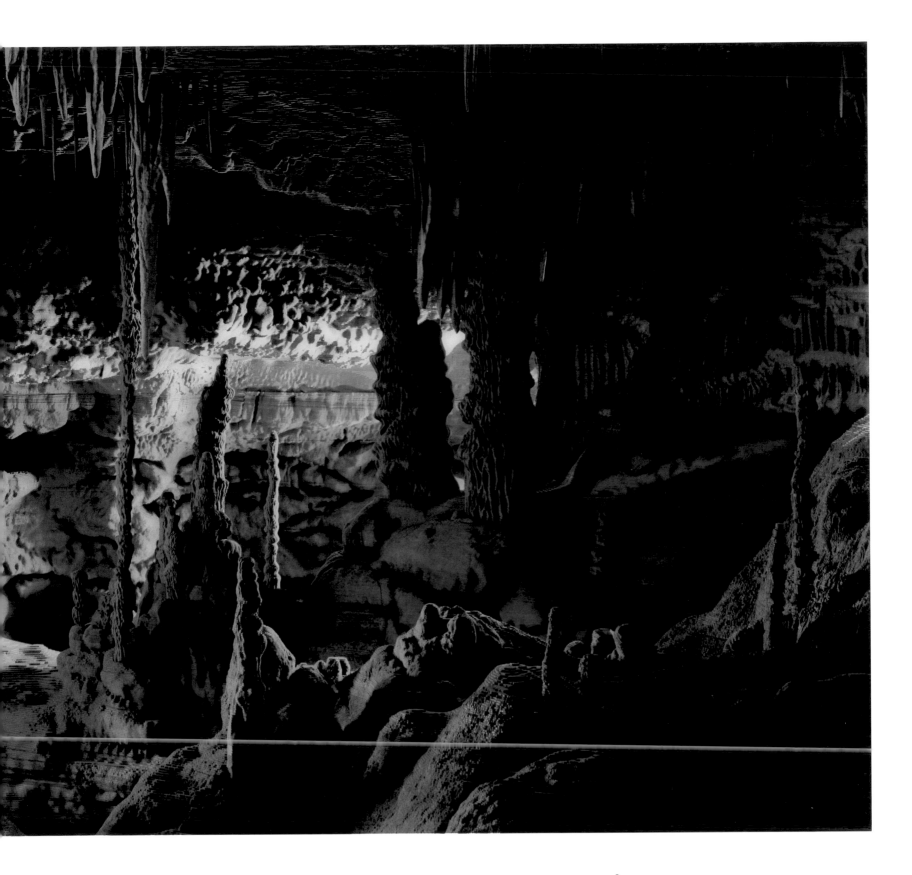

2
Thomas Demand
Grotto, 2006
C-print mounted
on Plexiglas

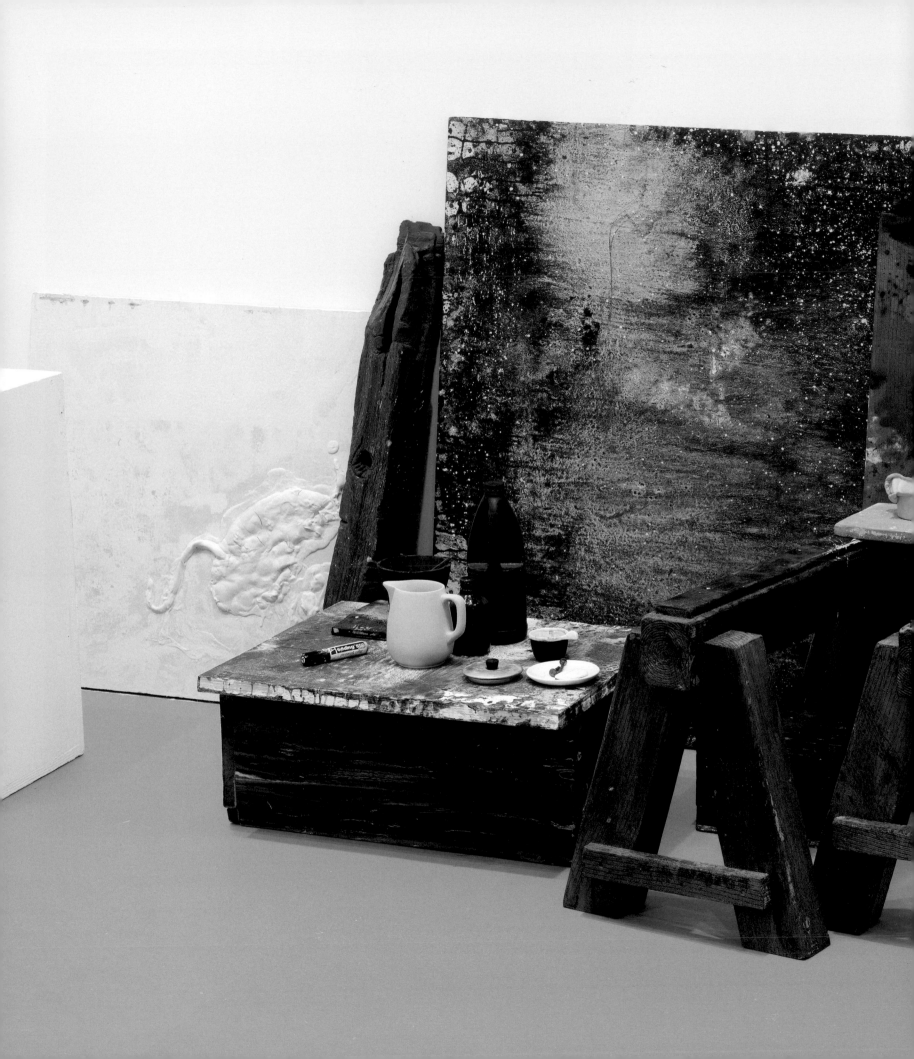

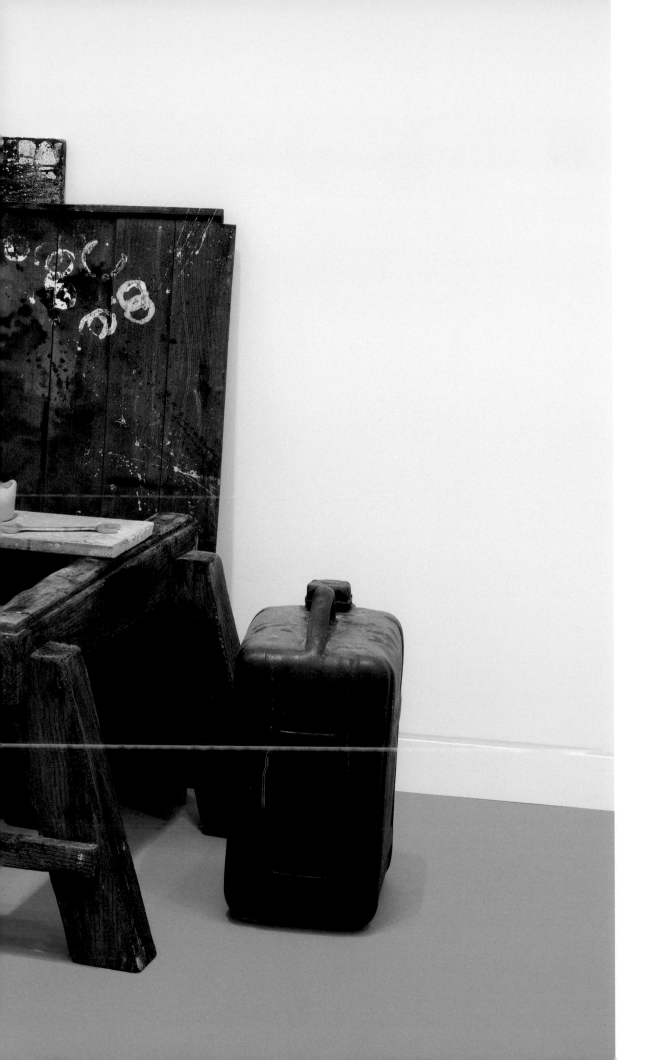

3
—
Peter Fischli David Weiss
The Objects for Glenstone
2010–11
Hand-carved polyurethane
and acrylic paint

(pages 62–71)

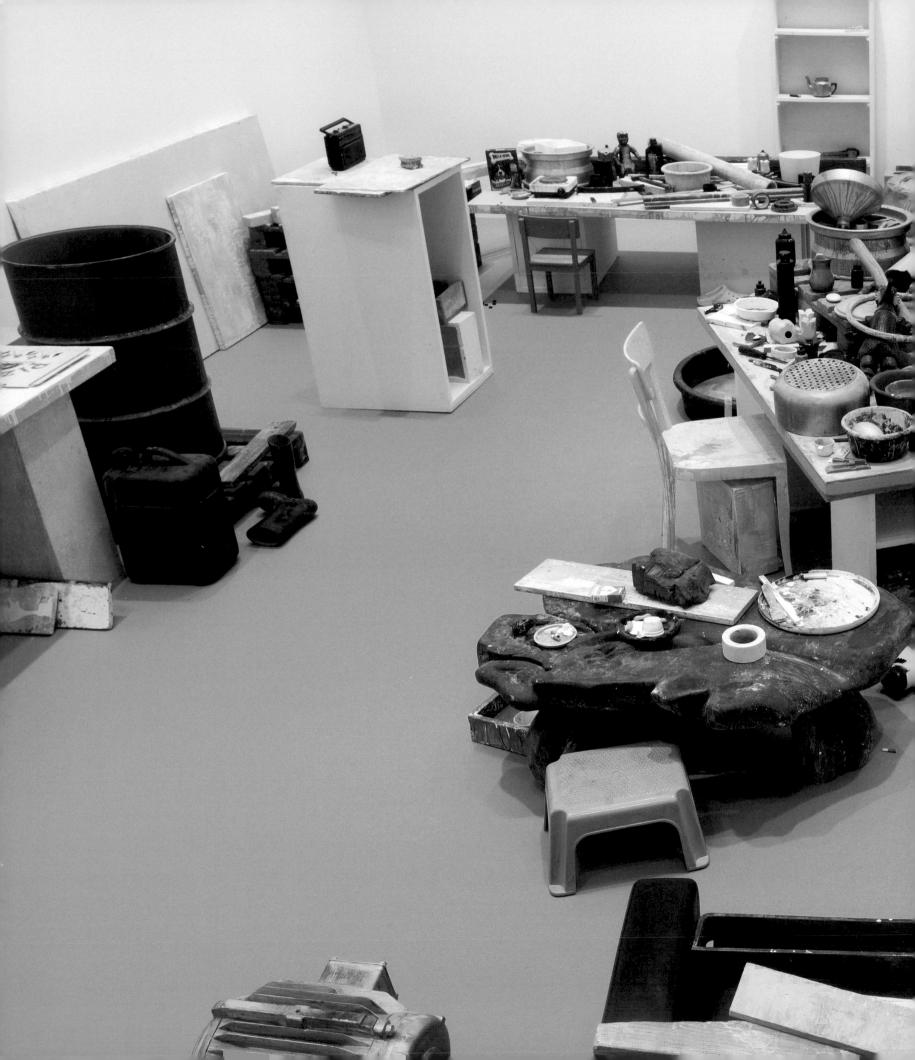

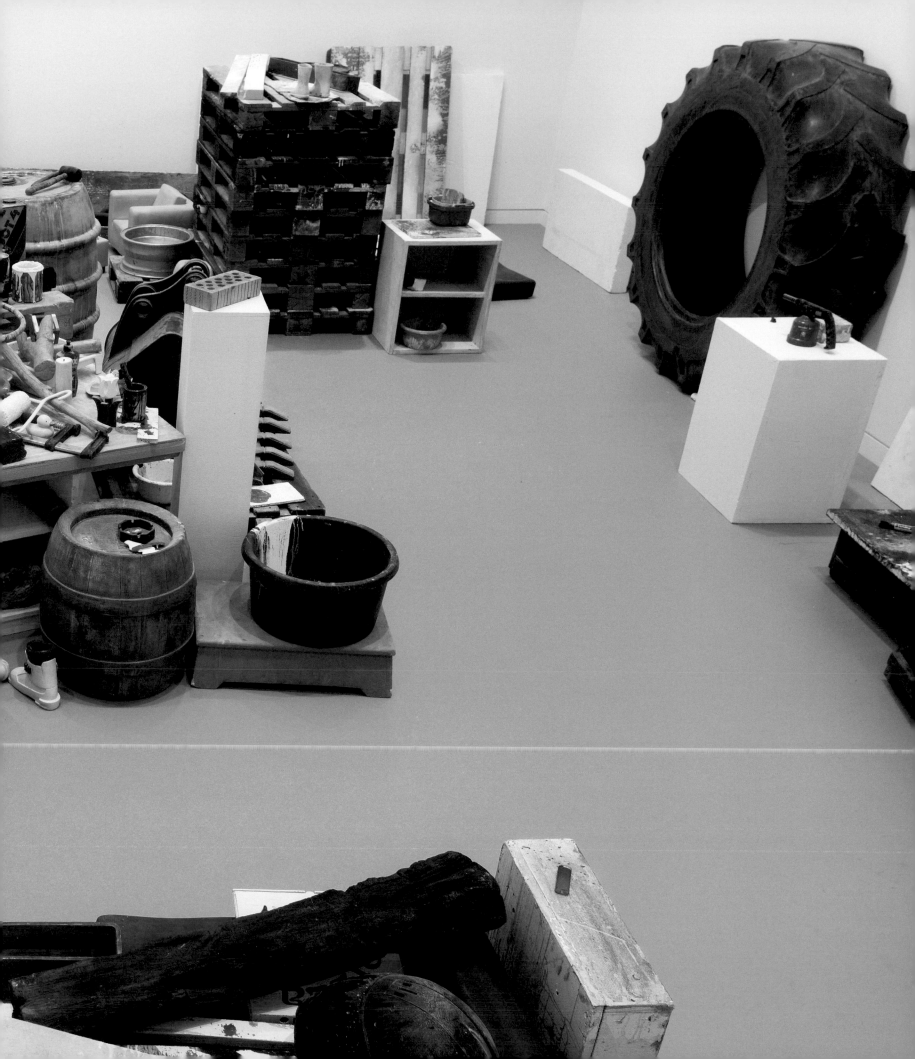

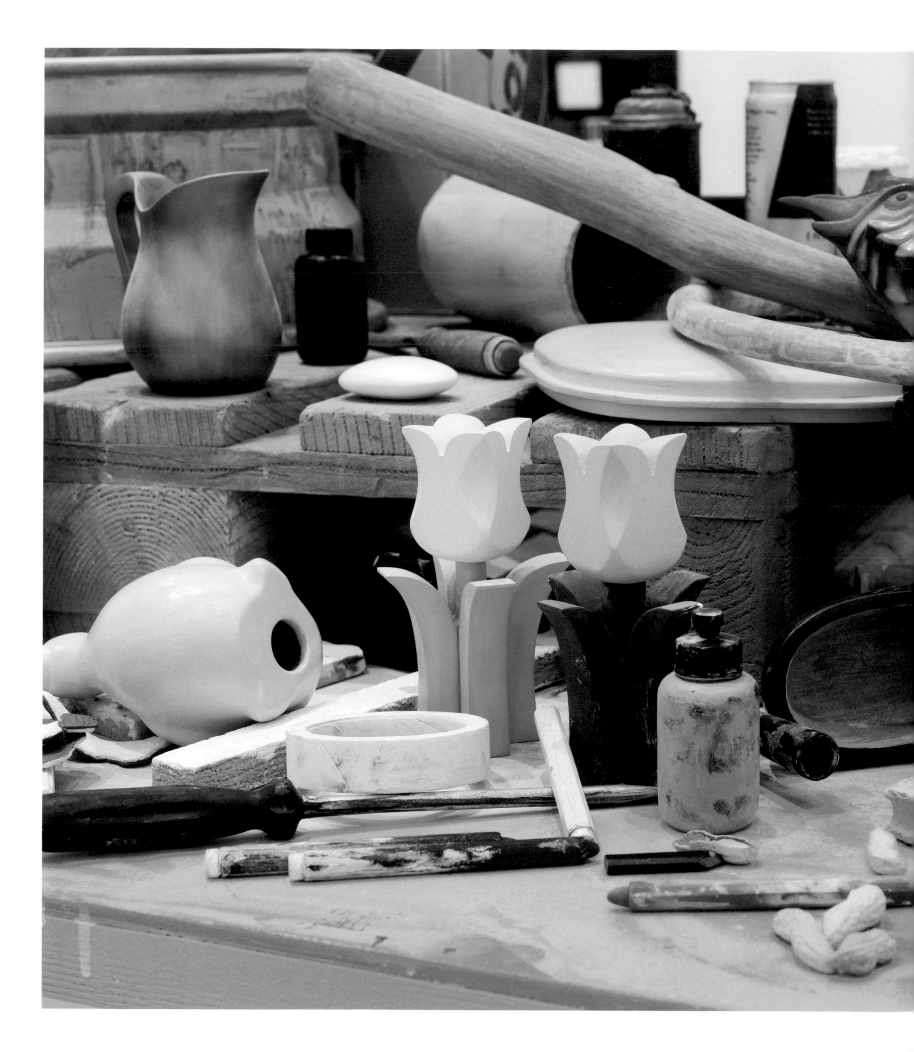

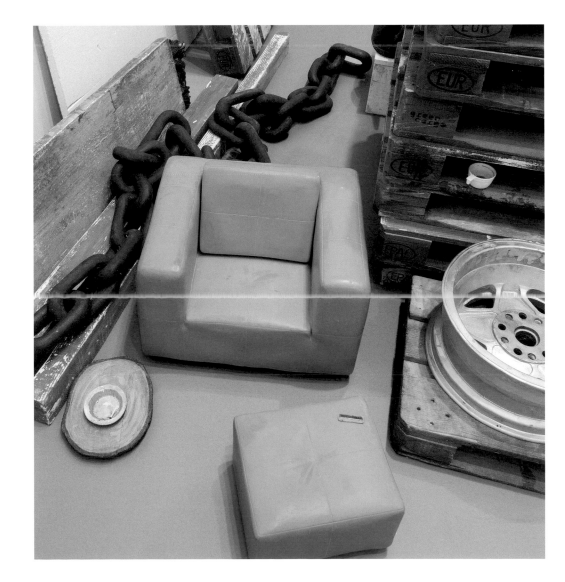

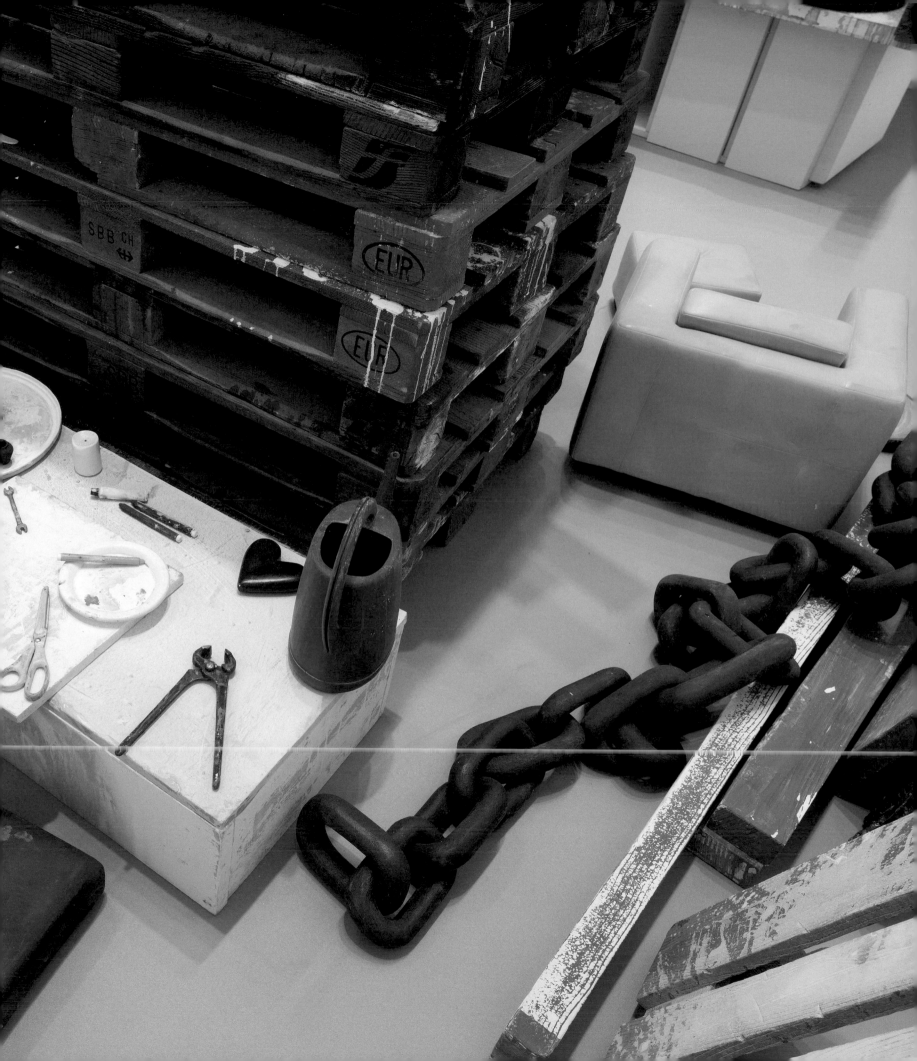

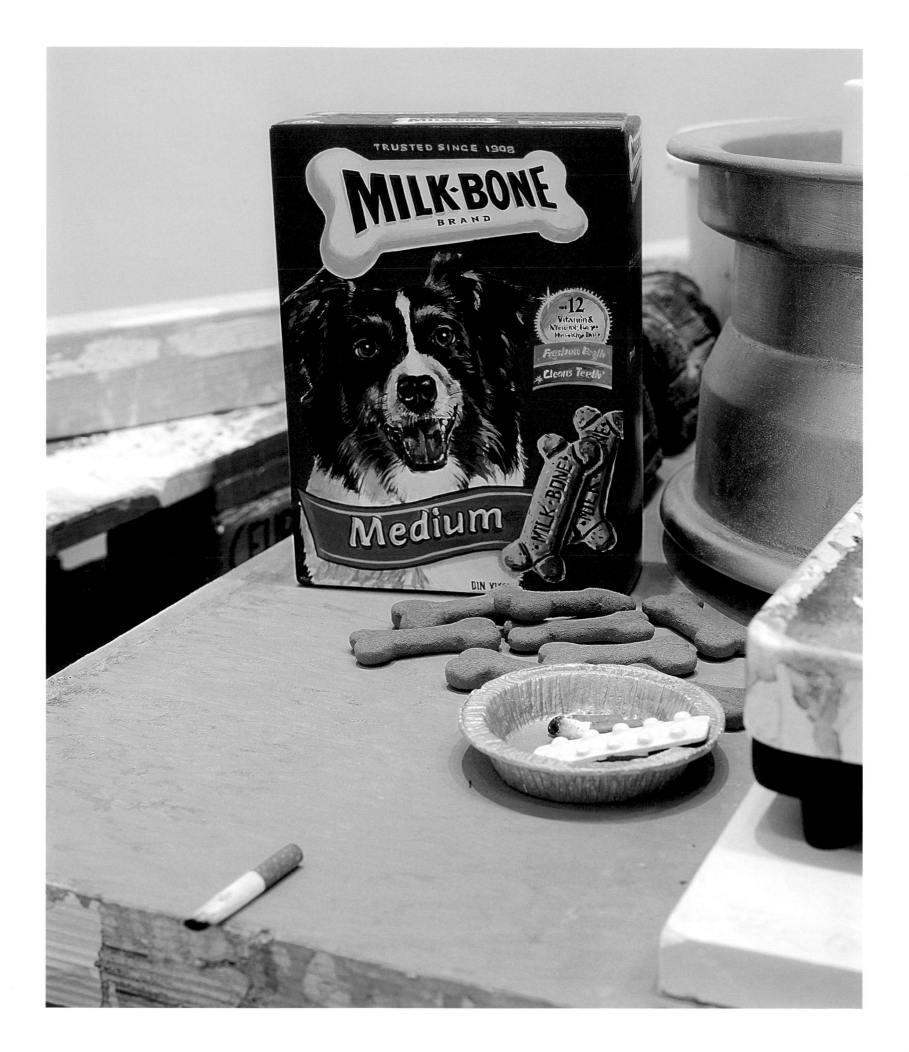

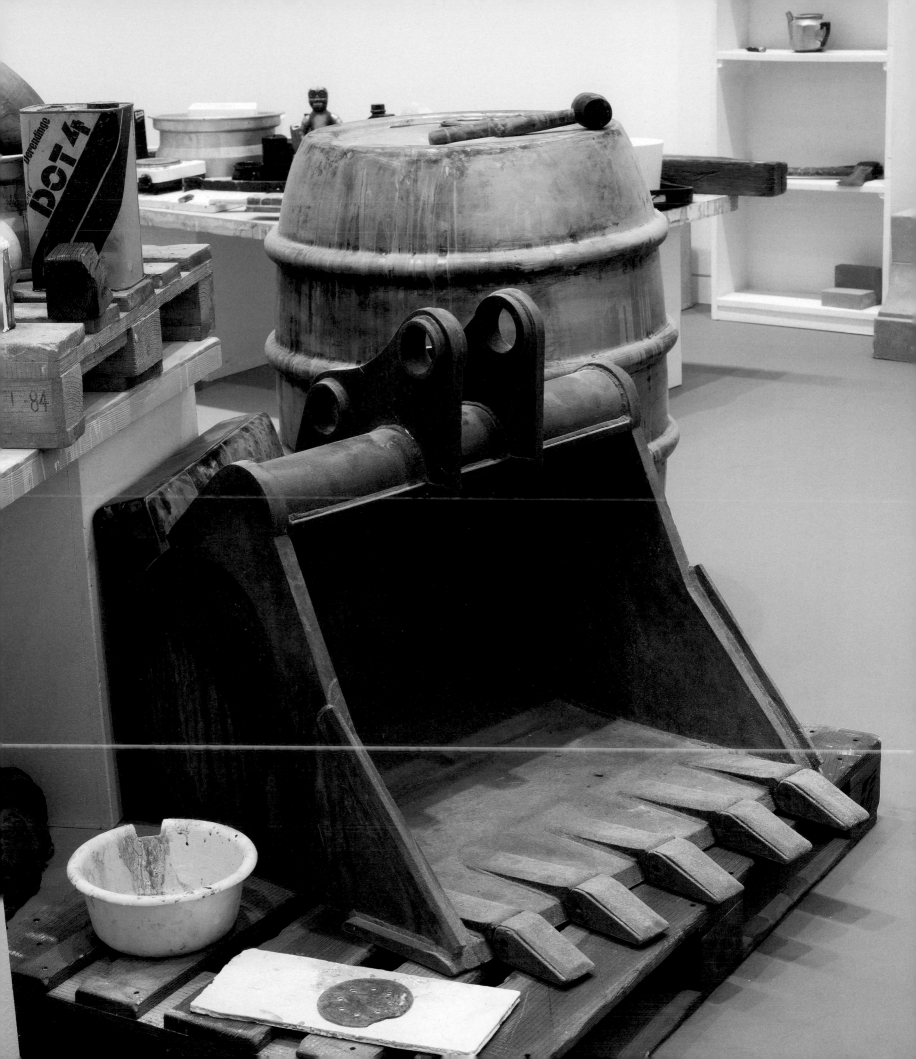

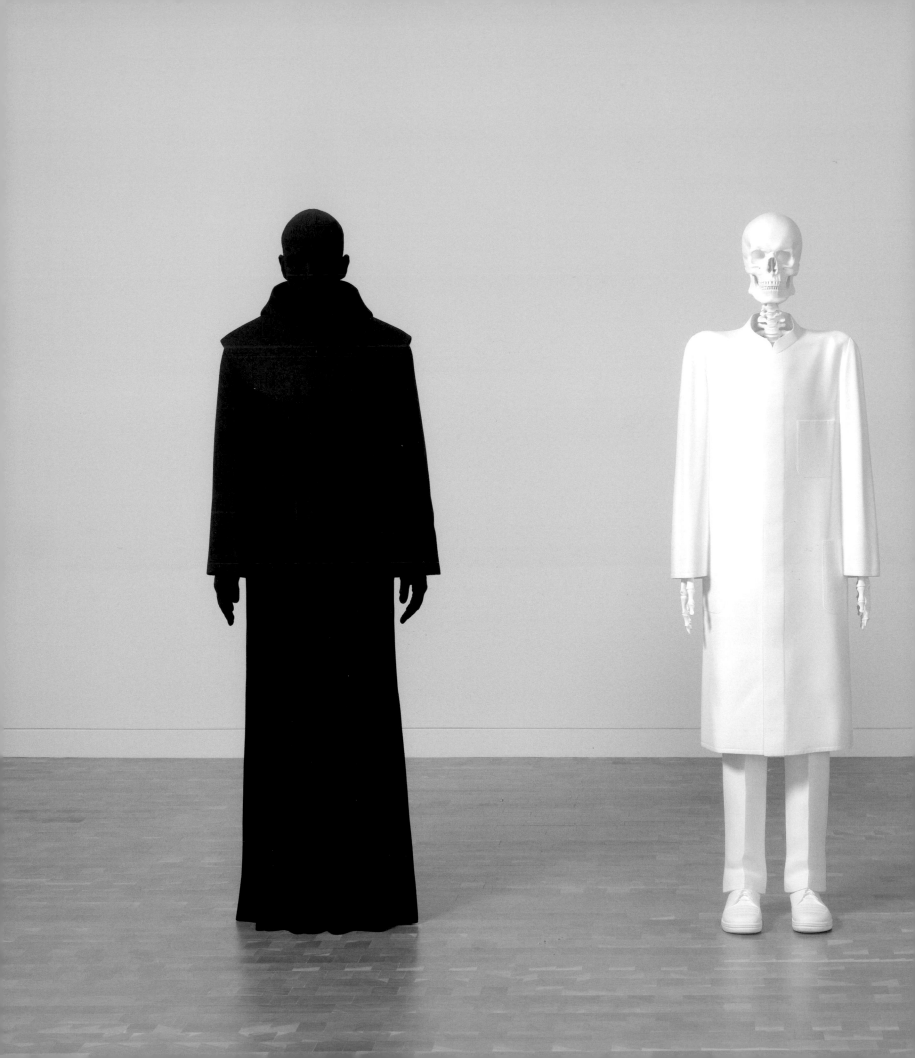

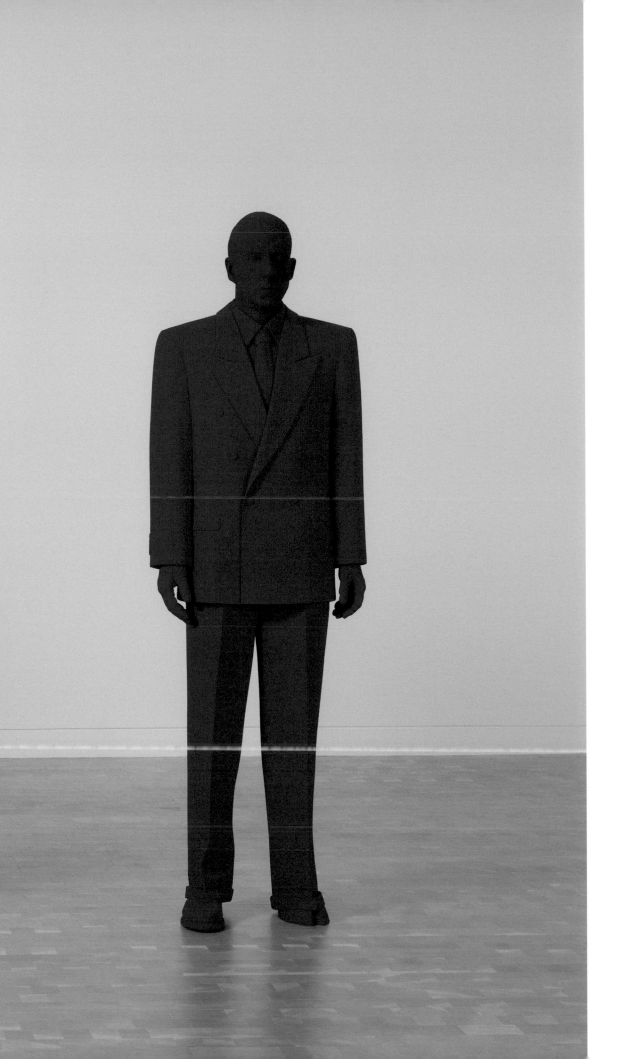

4
—
Katharina Fritsch
Mönch [Monk], 1997–99
Polyester and paint

5
—
Katharina Fritsch
Doktor [Doctor], 1997–99
Polyester and paint

6
—
Katharina Fritsch
Händler [Dealer], 2001
Polyester and paint

(pages 72–77)

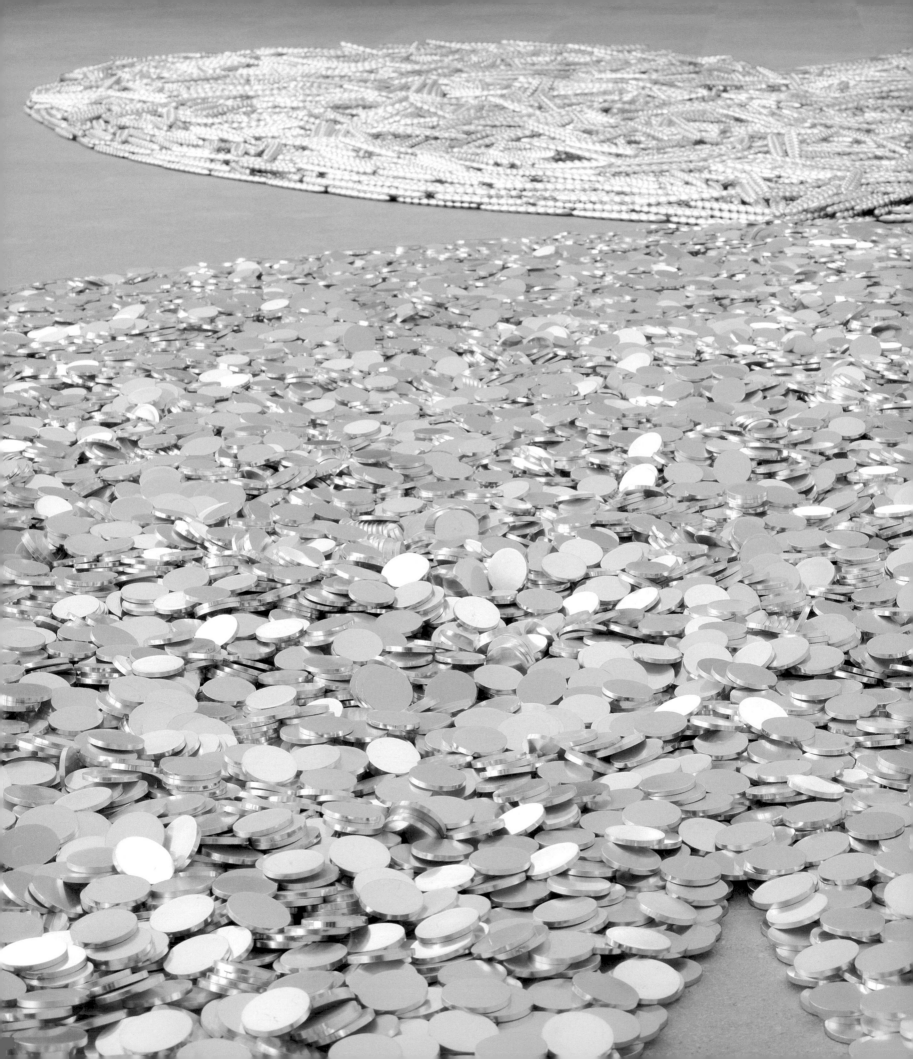

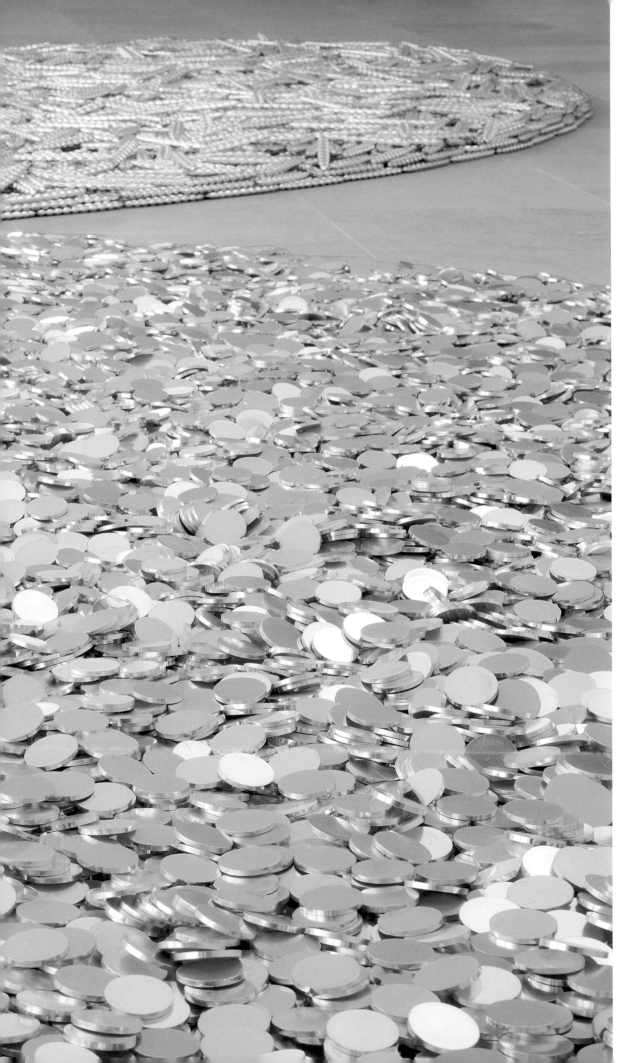

7
—
Katharina Fritsch
*Herz mit Geld und Herz
mit Ähren* [Heart with
Money and Heart
with Wheat], 1998–99
Plastic, aluminum,
and paint

(pages 78–81)

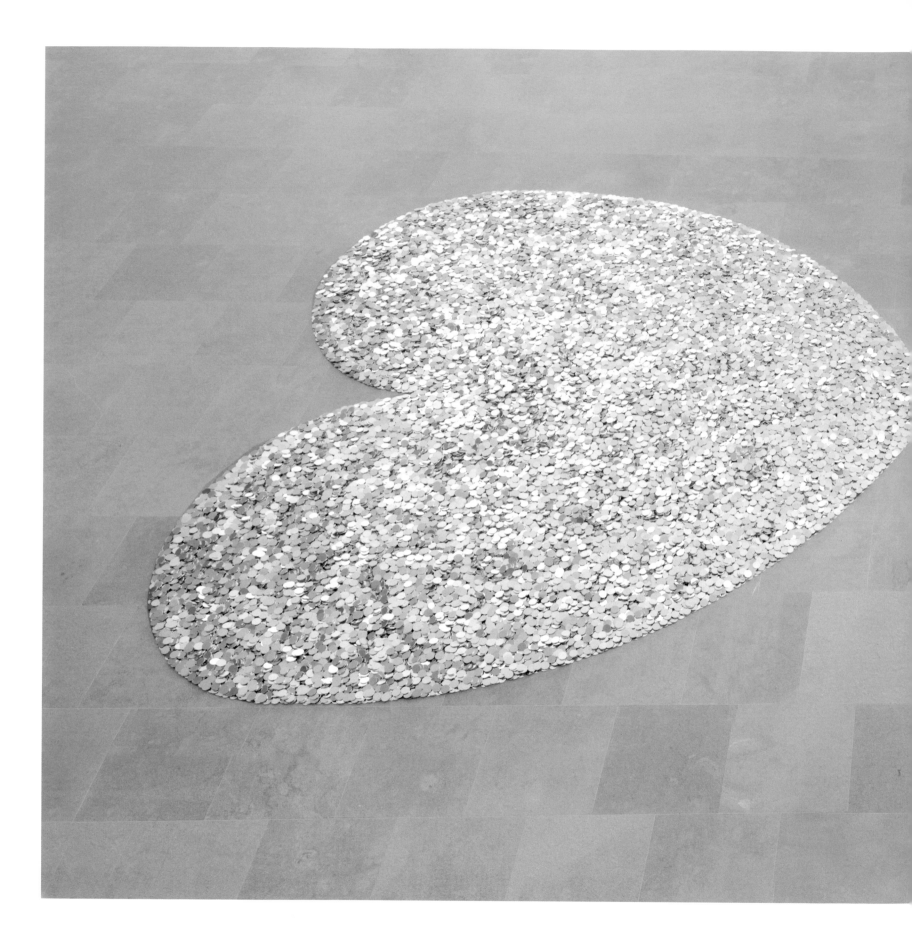

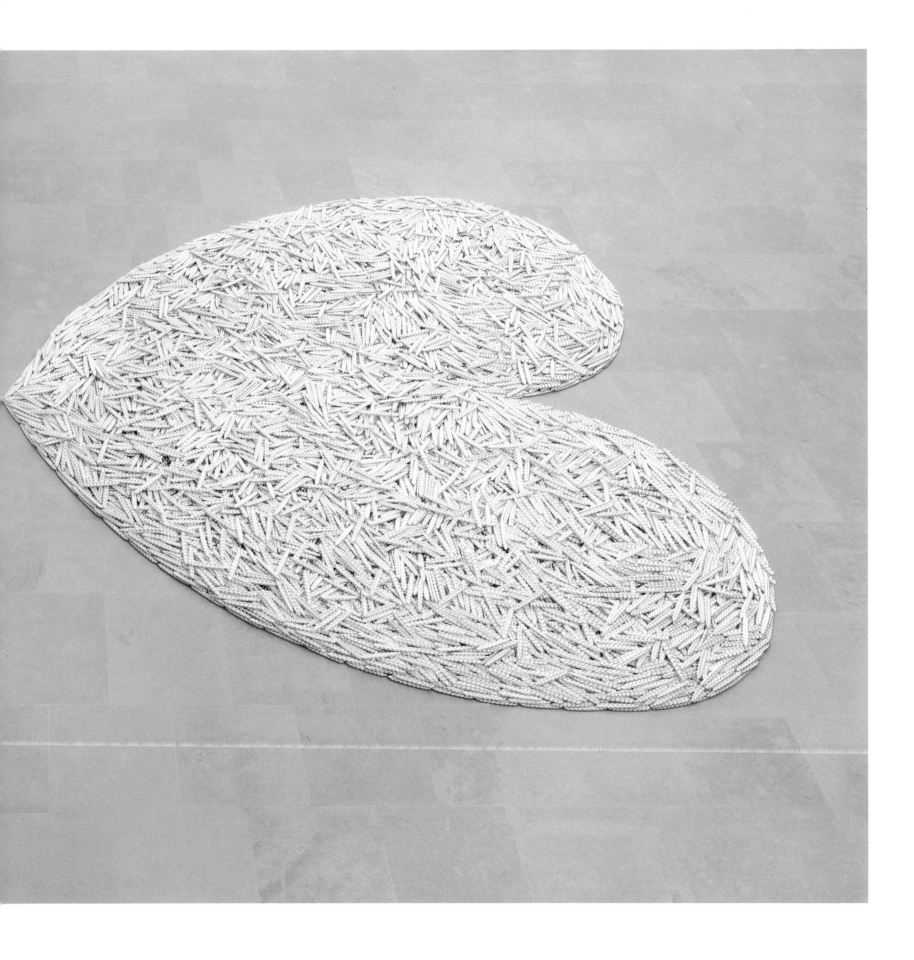

8
—
Robert Gober
The Silly Sink, 1985
Plaster, wood, steel, wire lath,
and semigloss enamel paint

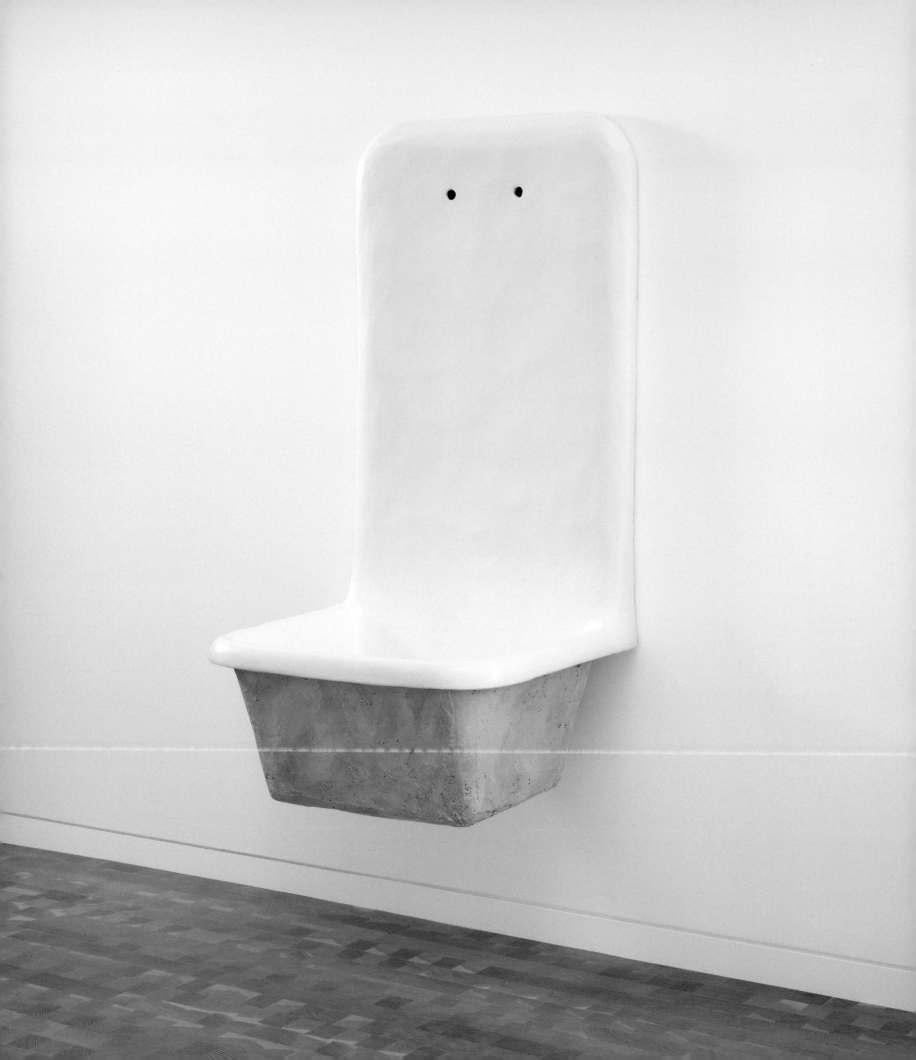

9
—
Robert Gober
The Kaleidoscopic Sink,
1985
Plaster, wood, steel,
wire lath, and semigloss
enamel paint

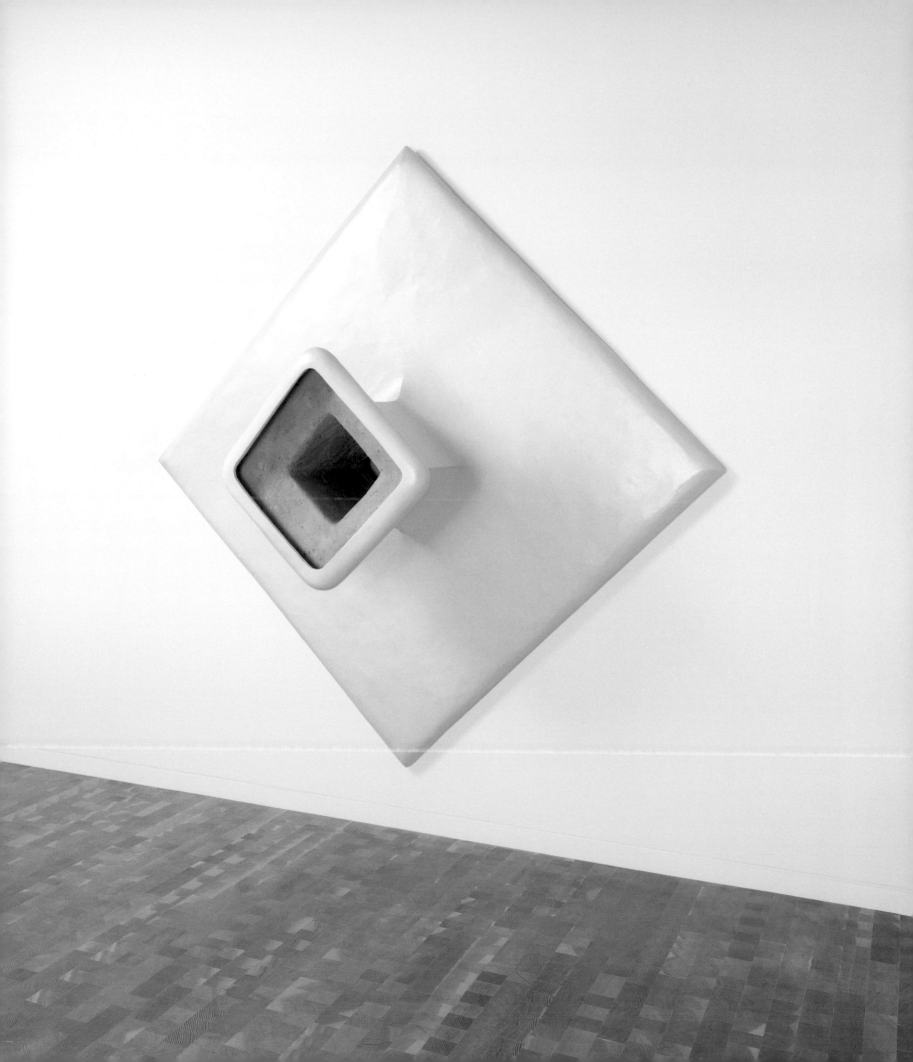

10
__

Robert Gober
Two Urinals, 1986
Plaster, wire lath, wood,
and enamel paint

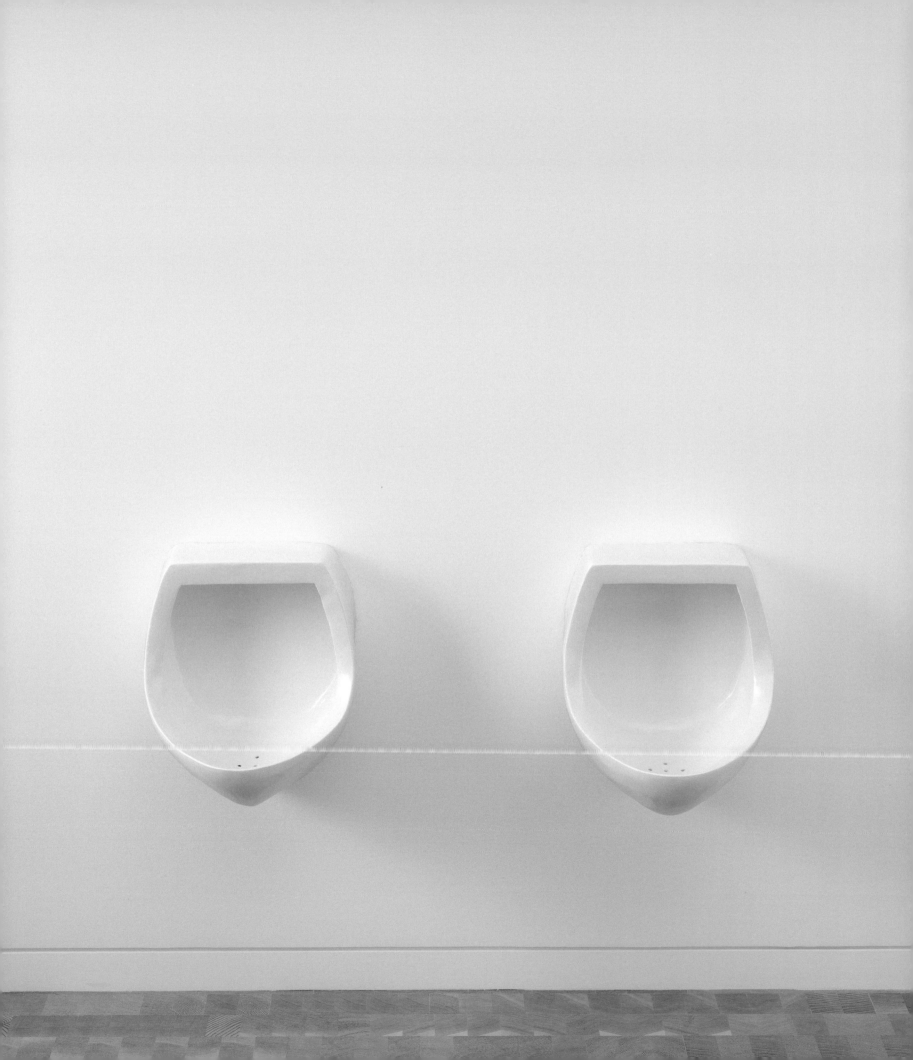

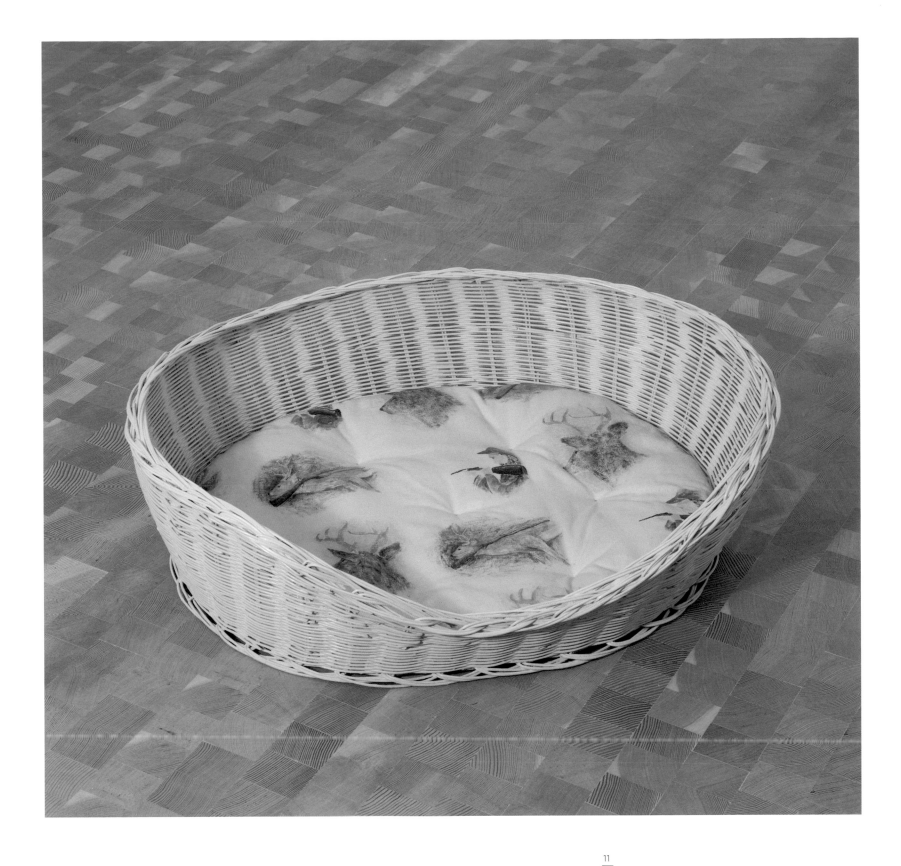

11
—
Robert Gober
Untitled, 1987
Handwoven rattan, cotton,
flannel, and fabric paint

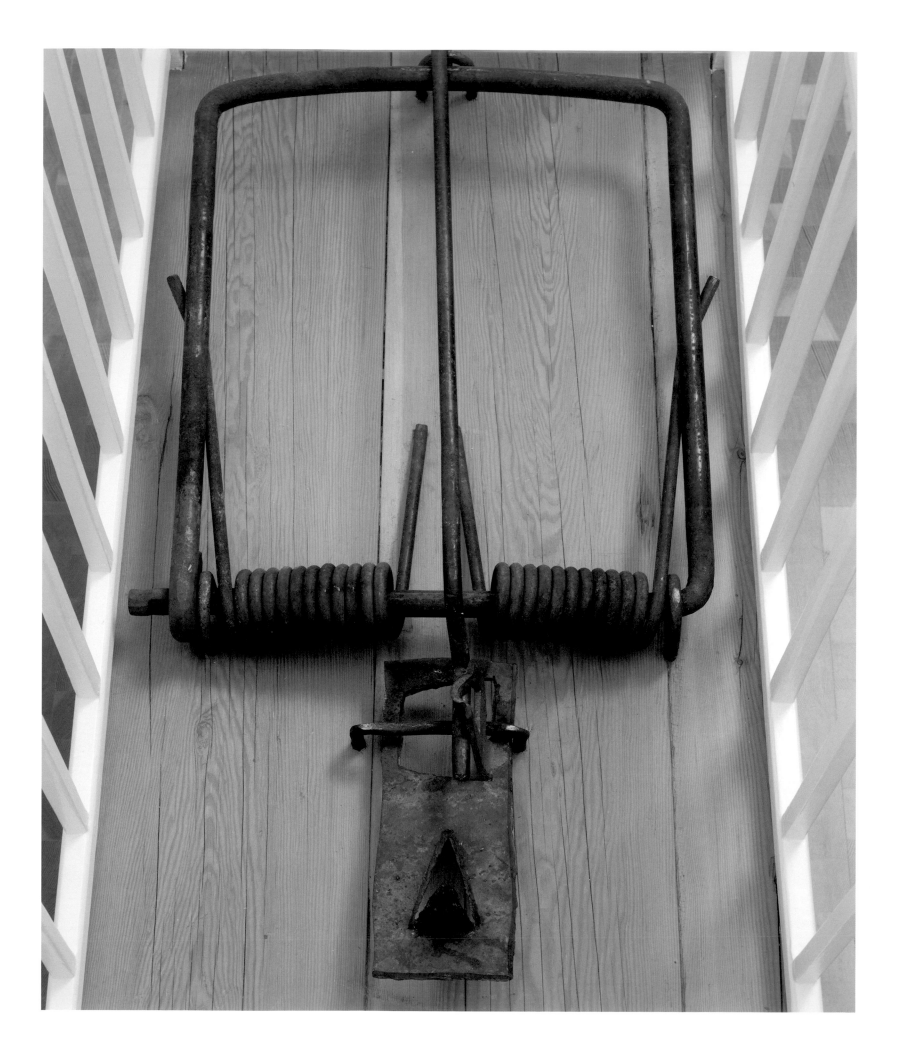

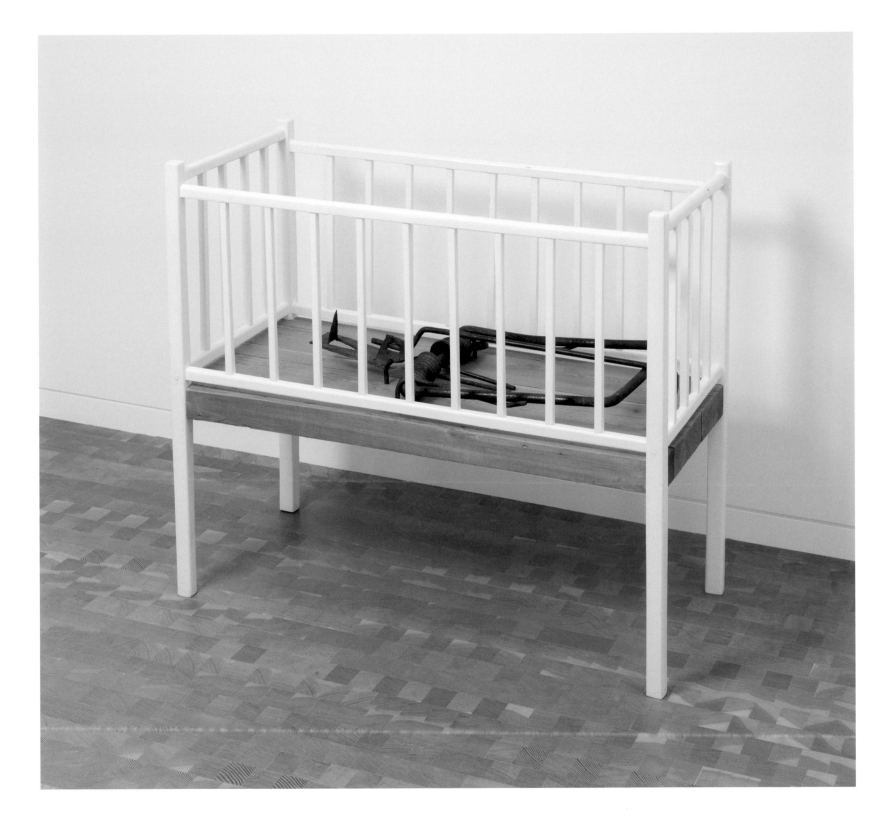

12

Robert Gober
Going For The Cheese
1992–93
Oak, fir, steel, and
enamel paint

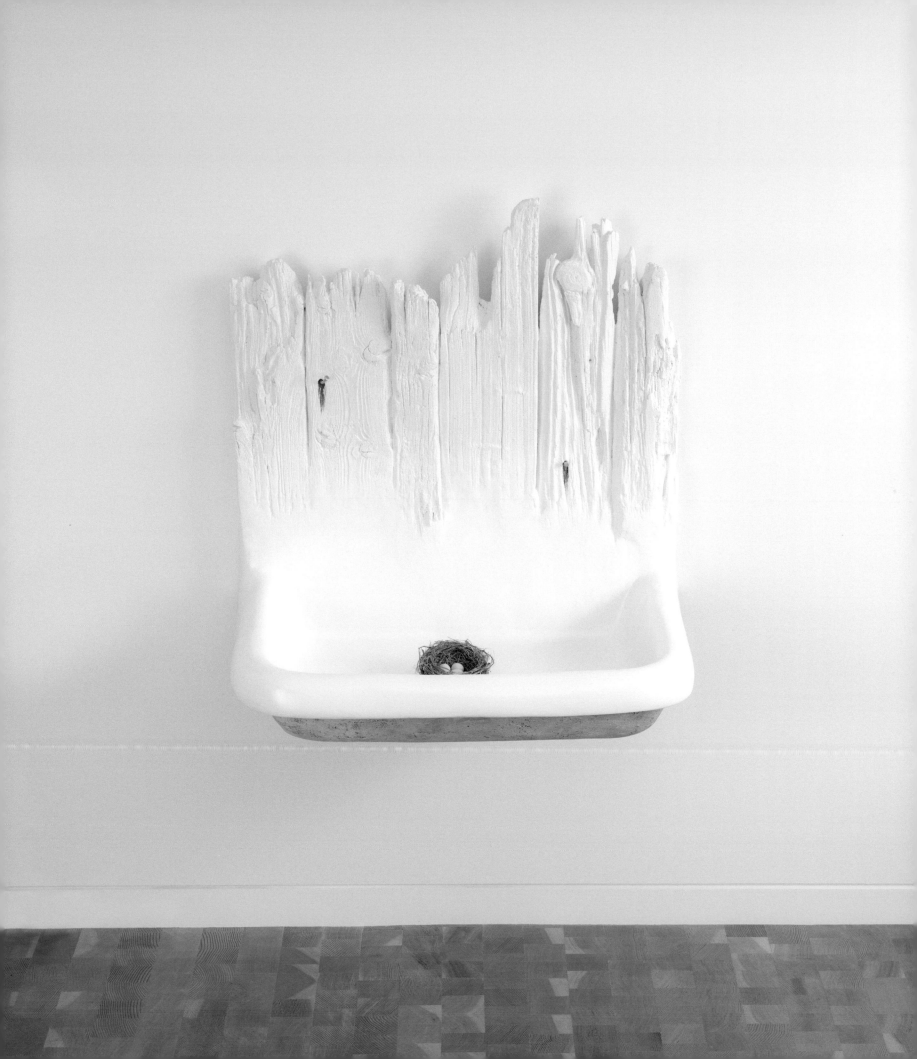

14
—

Robert Gober
Leg with Anchor, 2008
Forged iron and steel,
beeswax, cotton, leather,
and human hair

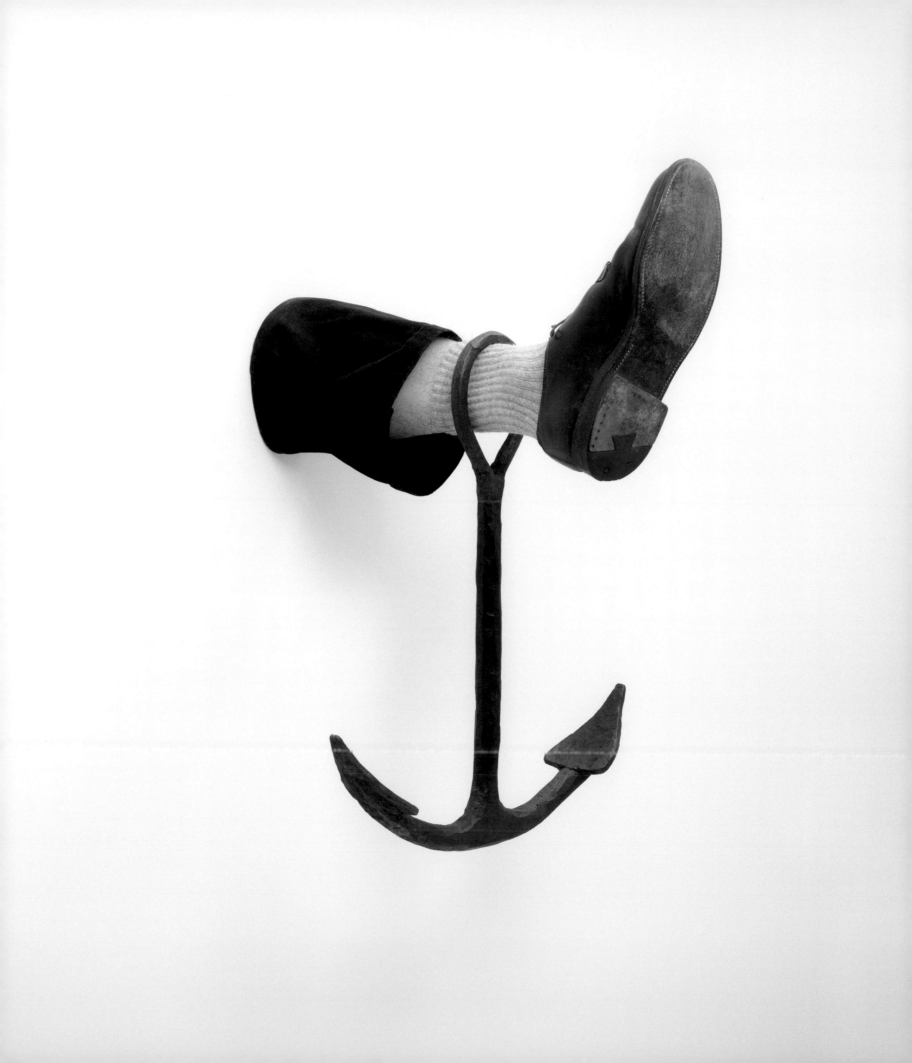

15

Damien Hirst
Is Nothing Sacred, 1997
Glass, painted MDF, ramin,
steel, nickel-plated steel,
aluminum, sliding door
locks with key, and
pharmaceutical packaging

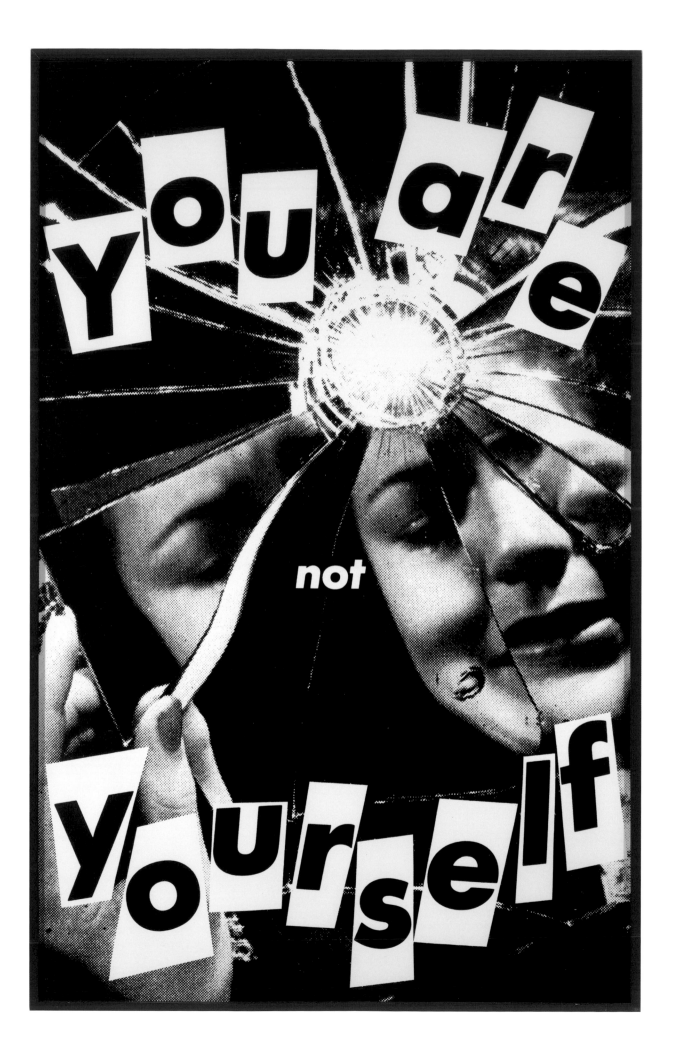

16
Barbara Kruger
Untitled (You Are Not Yourself), 1982
Gelatin silver print

17
Barbara Kruger
Untitled (I Shop Therefore I Am), 1987
Photographic silkscreen on vinyl

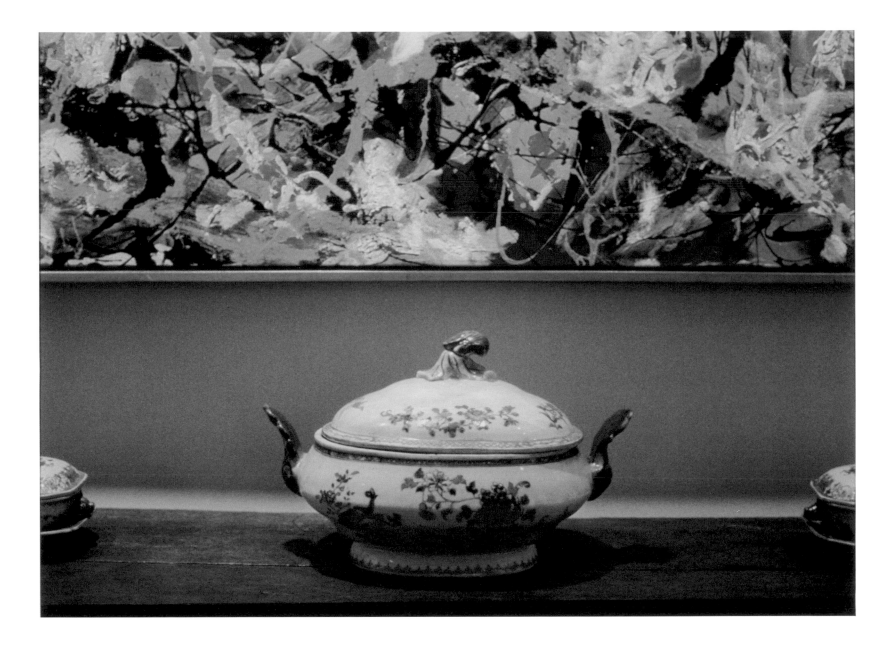

18

Louise Lawler
*Pollock and Tureen, Arranged
by Mr. & Mrs. Burton
Iremaine, Connecticut*, 1984
Cibachrome print

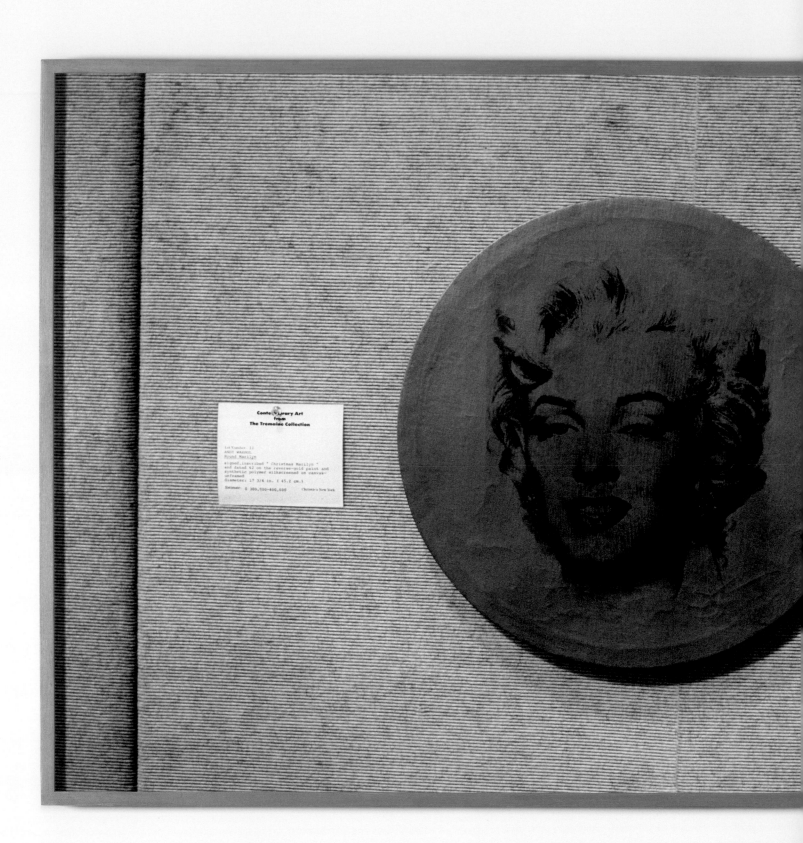

19

Louise Lawler
*Does Andy Warhol Make
You Cry?*, 1988
Cibachrome print and
Plexiglas wall label

DOES ANDY WARHOL
MAKE YOU CRY ?

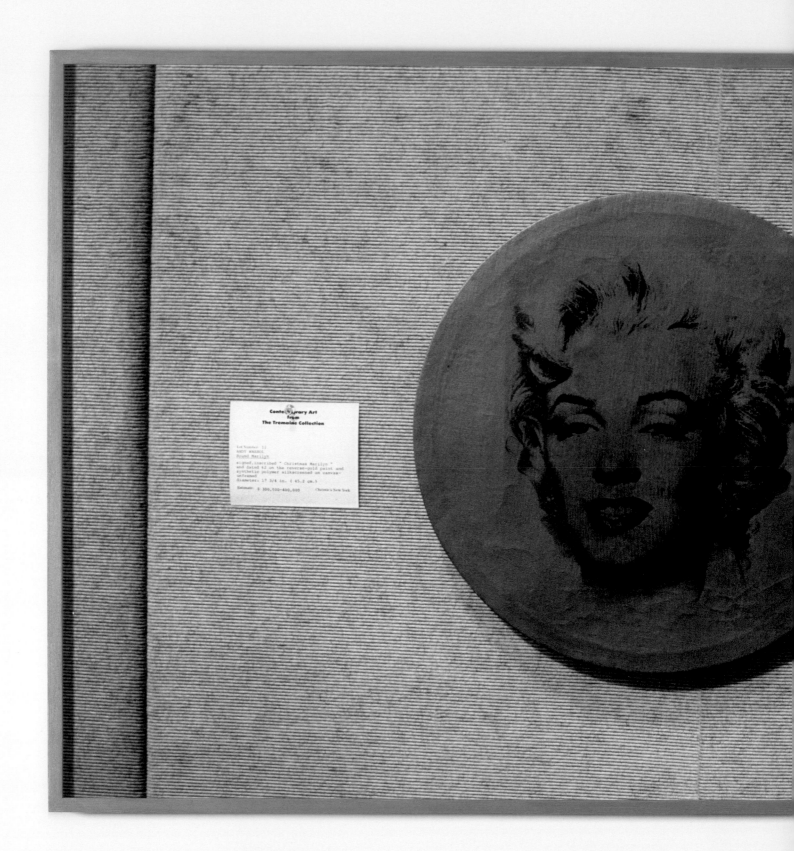

Contemporary Art
from
The Tramaine Collection

Lot Number: 13
ANDY WARHOL
Round Marilyn

signed, inscribed " Christmas Marilyn "
and dated 62 on the reverse-gold paint and
synthetic polymer silkscreened on canvas-
unframed
diameter: 17 3/4 in. (45.2 cm.)

Estimate: $ 300,500-400,000 Christie's New York

20

Louise Lawler
*Does Marilyn Monroe
Make You Cry?*, 1988
Cibachrome print and
Plexiglas wall label

DOES MARILYN MONROE
MAKE YOU CRY ?

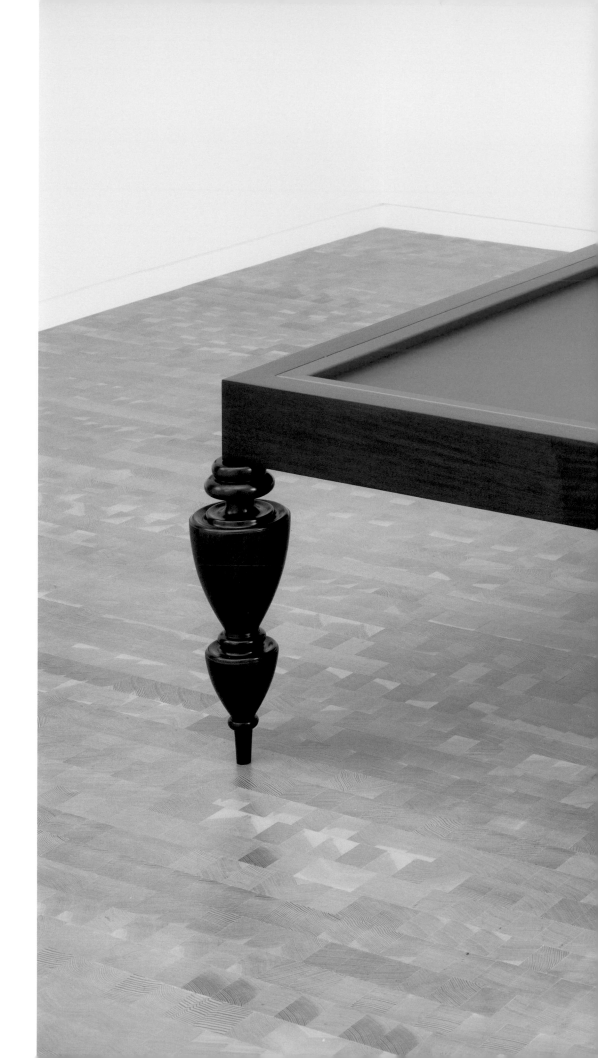

21

Sherrie Levine
La Fortune (After Man Ray):
AP1, 1990
Felt, mahogany, and resin

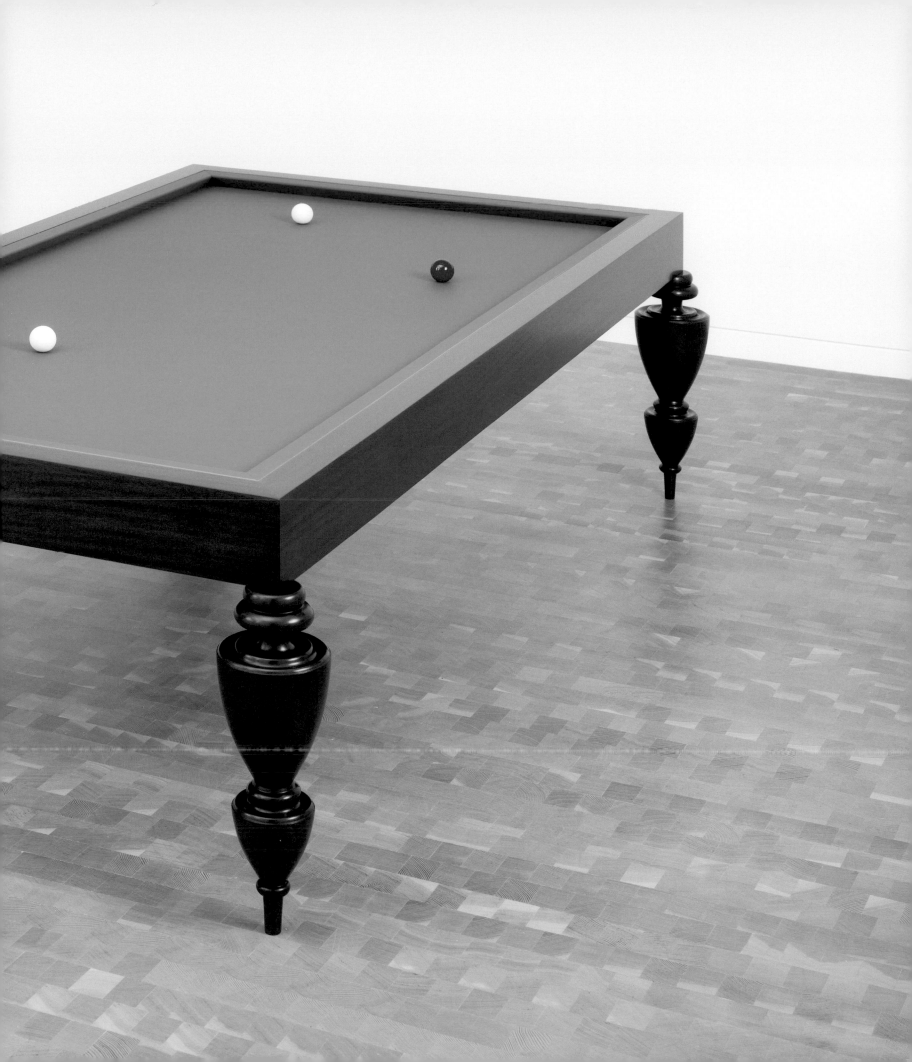

Sherrie Levine
Fountain (After Marcel
Duchamp): 1, 1991
Bronze and artist's
wooden base

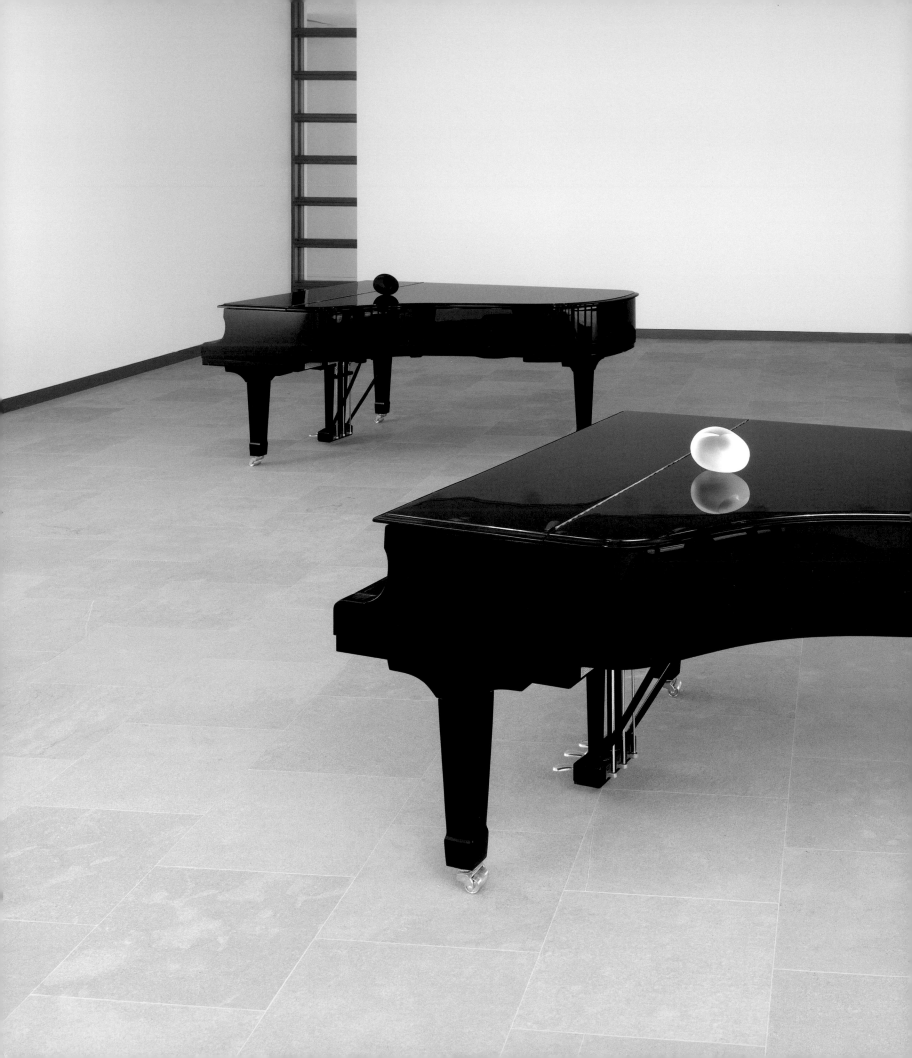

23
Sherrie Levine
Black Newborn: 1, 1994
Cast and sandblasted
glass on grand piano

24
Sherrie Levine
Crystal Newborn: 4, 1993
Cast and sandblasted
glass on grand piano

(pages 110–113)

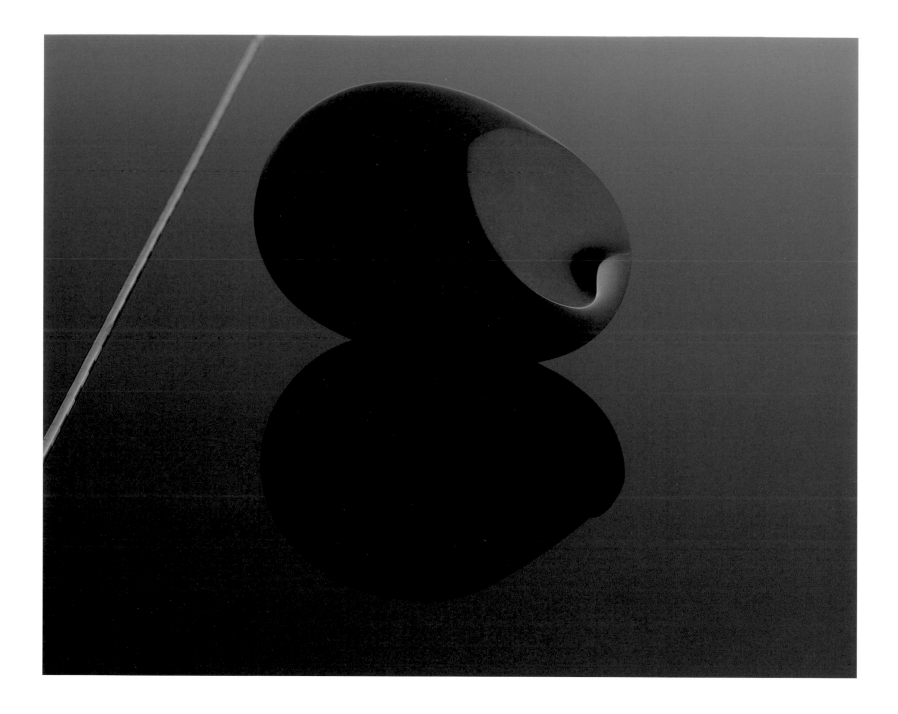

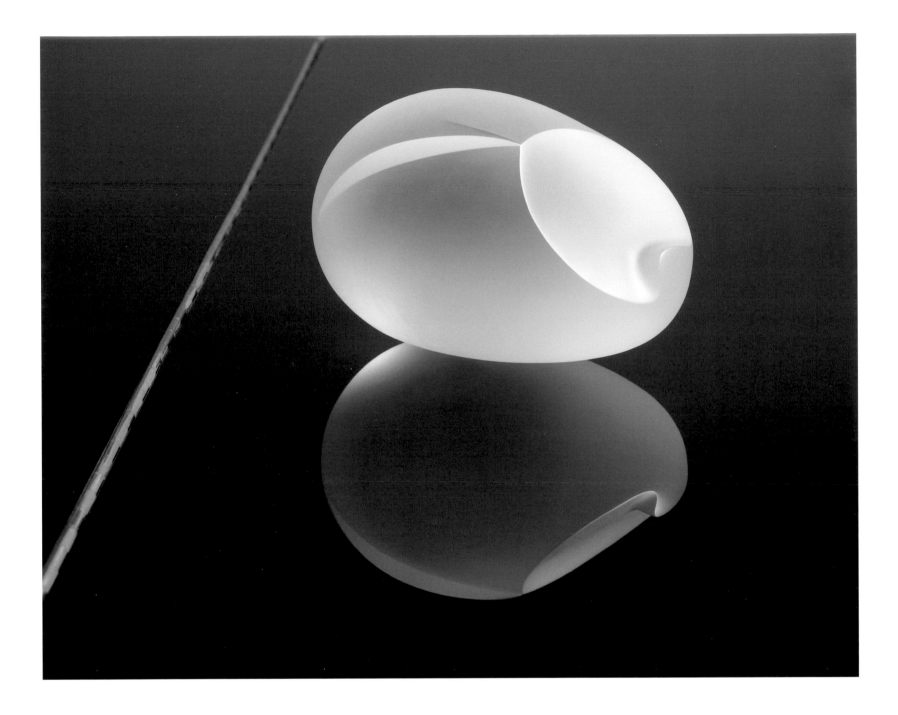

25
—
Richard Prince
Untitled (three women looking in the same direction), 1980
Ektacolor photographs

26

Richard Prince and
Cindy Sherman
*Untitled (Richard Prince
and Cindy Sherman)*, 1980
Ektacolor photographs

27
—

Charles Ray
Untitled (Tractor)
2003–2005
Cast aluminum

(pages 118–121)

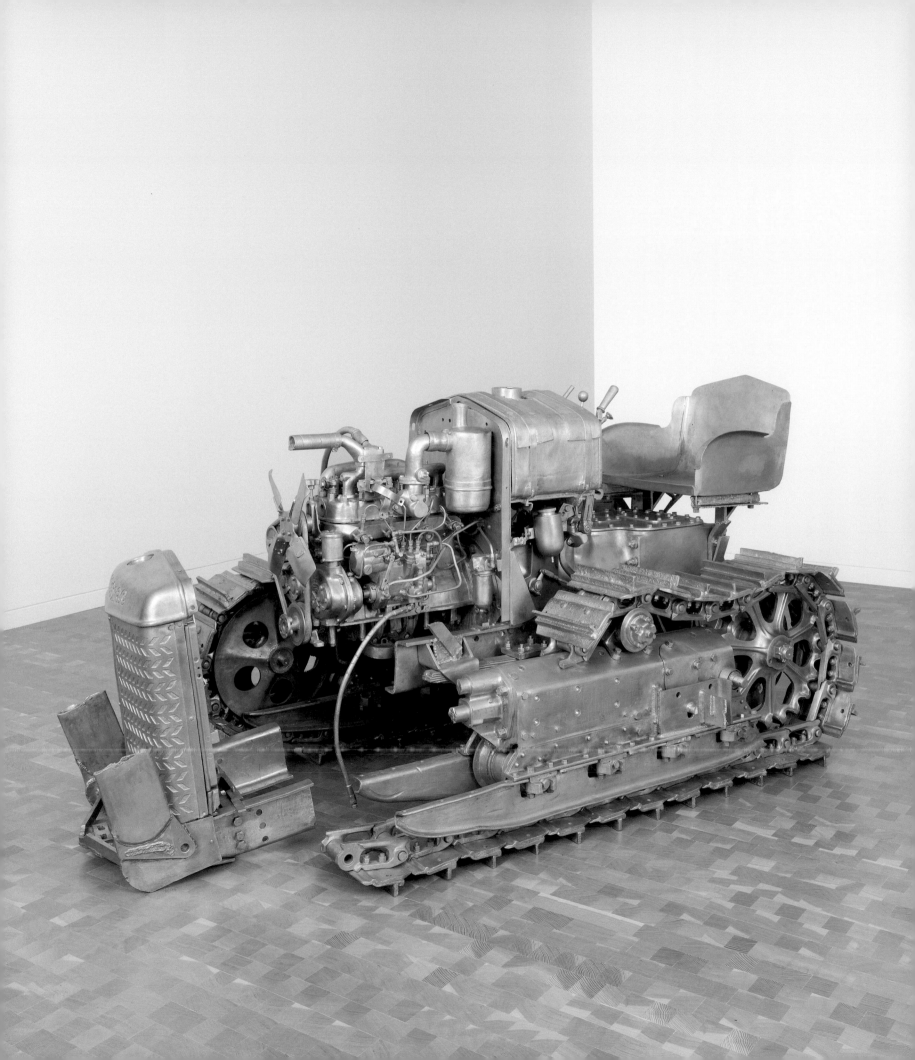

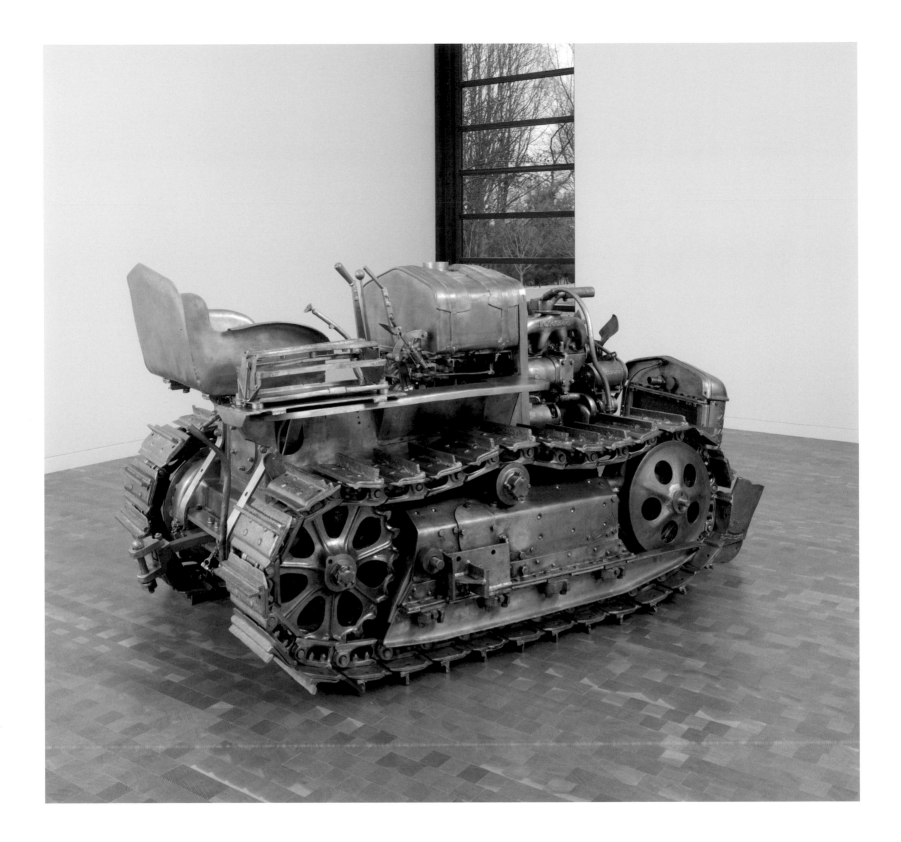

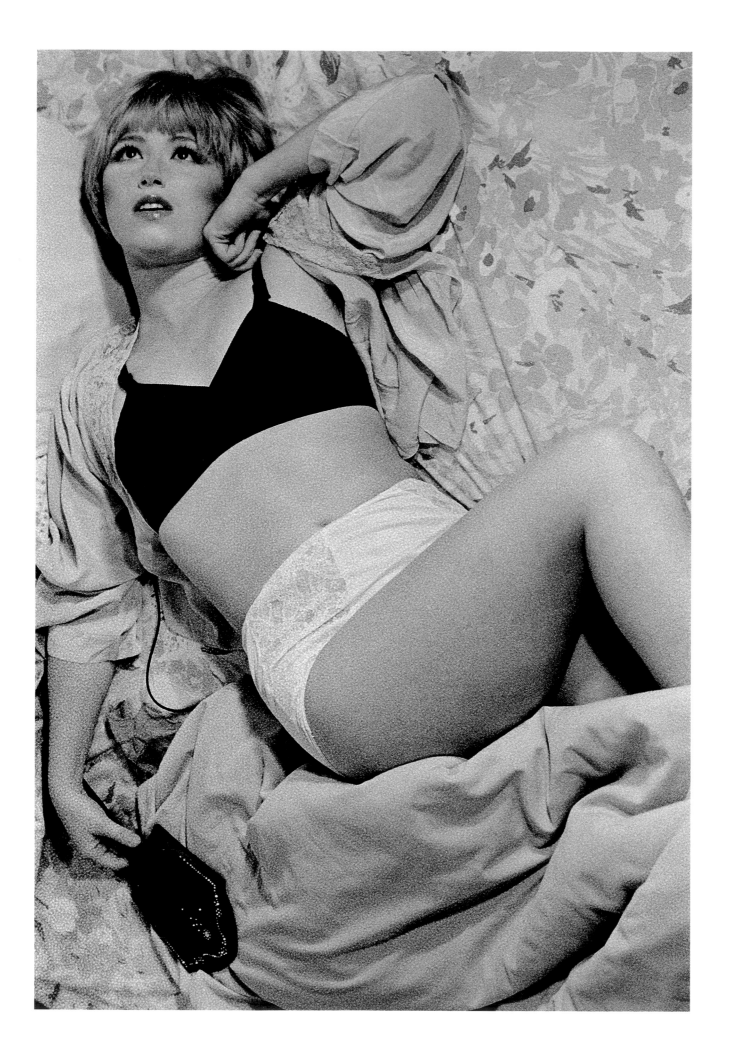

28
Cindy Sherman
Untitled Film Still, 1977
Gelatin silver print

29
Cindy Sherman
Untitled Film Still, 1979
Gelatin silver print

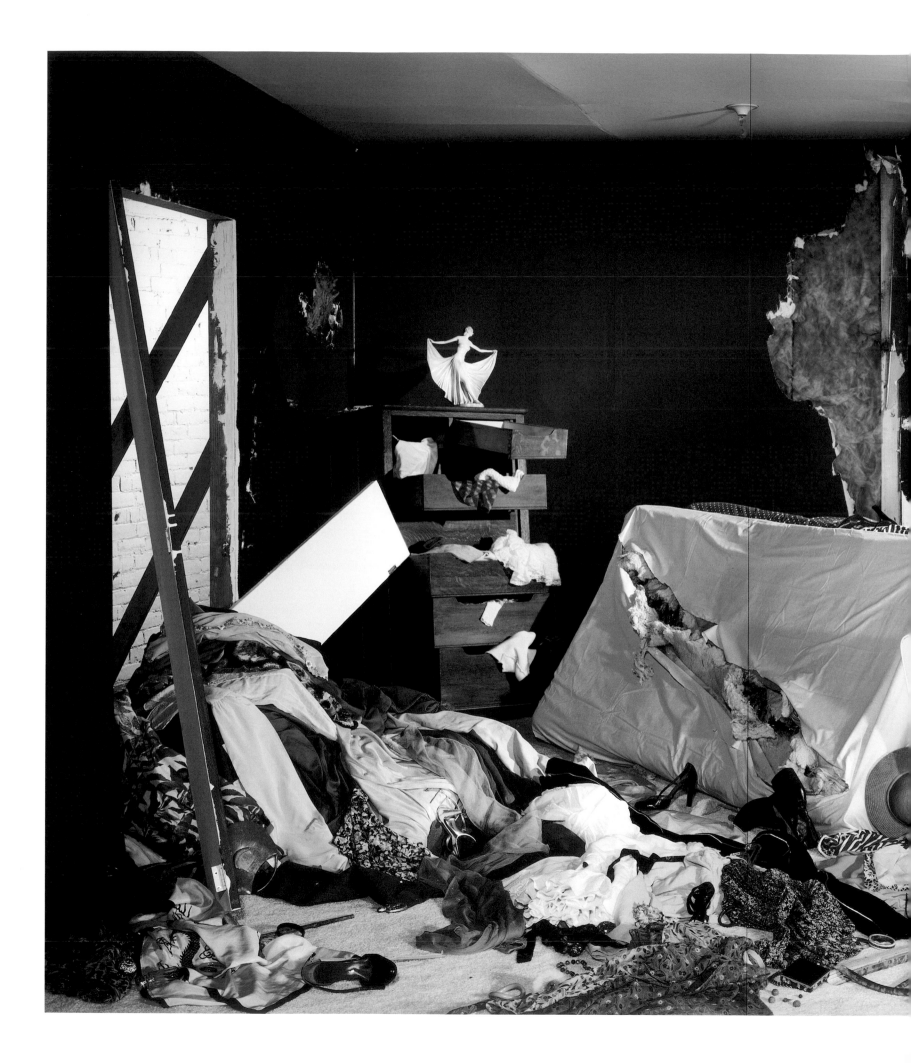

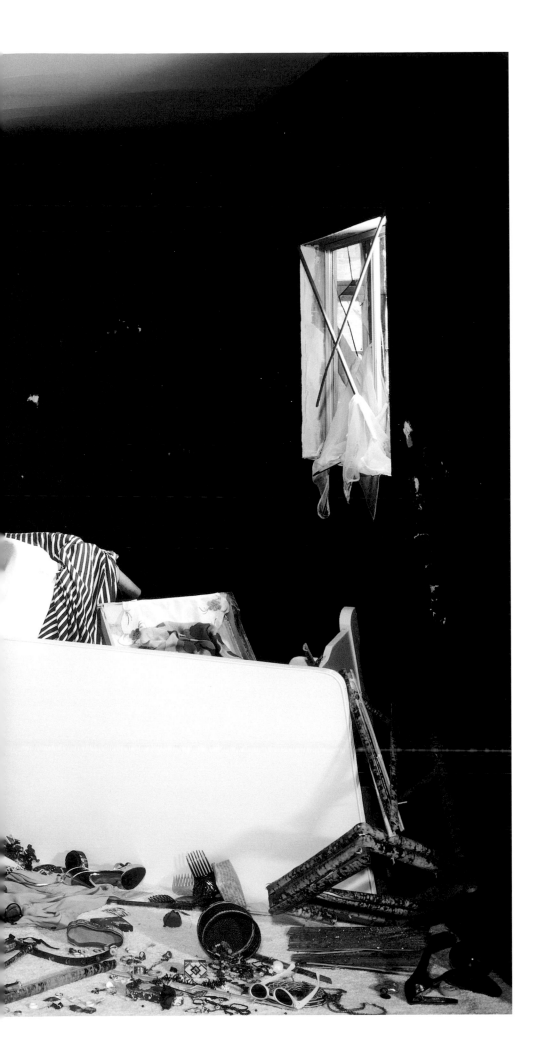

30

Jeff Wall
The Destroyed Room, 1978
Transparency in light box

31
Jeff Wall
An Eviction, 1988/2004
Transparency in light box

32
Jeff Wall
Rear view, open-air theatre,
Vancouver, 2005
Transparency in light box

Checklist

Thomas Demand
b. Munich, Germany, 1964

Leuchtkasten [Light Box], 2004
C-print mounted on Plexiglas
60 × 114 ¼ × 1 ¼ inches
(152.4 × 290.2 × 3.2 cm)

Grotto, 2006
C-print mounted on Plexiglas
78 × 173 ½ × 1 ½ inches
(198.1 × 440.7 × 3.8 cm)

Peter Fischli David Weiss
b. Zurich, Switzerland, 1952
b. Zurich, Switzerland, 1946

The Objects for Glenstone, 2010–11
Hand-carved polyurethane
and acrylic paint
Dimensions variable

Katharina Fritsch
b. Essen, Germany, 1956

Mönch [Monk], 1997–99
Polyester and paint
75 ½ × 24 ⅞ × 18 ⅛ inches
(192 × 63 × 46 cm)

Doktor [Doctor], 1997–99
Polyester and paint
75 ½ × 22 × 14 ½ inches
(192 × 56 × 37 cm)

Händler [Dealer], 2001
Polyester and paint
75 × 23 ¼ × 15 ¾ inches
(192 × 59 × 40 cm)

Herz mit Geld und Herz mit Ahren
[Heart with Money and Heart
with Wheat], 1998–99
Plastic, aluminum, and paint
156 × 312 inches
(396.2 × 792.5 cm)

Robert Gober
b. Wallingford, CT, 1954

The Silly Sink, 1985
Plaster, wood, steel, wire lath,
and semigloss enamel paint
66 × 33 × 29 inches
(167.6 × 83.8 × 73.7 cm)

The Kaleidoscopic Sink, 1985
Plaster, wood, steel, wire lath,
and semigloss enamel paint
70 ½ × 70 ½ × 28 inches
(179.1 × 179.1 × 71.1 cm)

Two Urinals, 1986
Plaster, wire lath, wood,
and enamel paint
19 × 15 × 15 inches
(48.3 × 38.1 × 38.1 cm) each
19 × 47 × 15 inches
(48.3 × 119.4 × 38.1 cm) overall

Untitled, 1987
Handwoven rattan, cotton,
flannel, and fabric paint
10 ⅜ × 38 ¼ × 30 inches
(26.4 × 97.2 × 76.2 cm)

Going For The Cheese, 1992–93
Oak, fir, steel, and enamel paint
48 ¾ × 53 ¼ × 27 inches
(123.8 × 135.3 × 68.6 cm)

Untitled, 2006–2007
Plaster, pewter, watercolor, oil paint,
ceramic, acrylic paint, twigs, and grass
34 × 33 ¾ × 22 ½ inches
(86.4 × 85.7 × 57.2 cm)

Leg with Anchor, 2008
Forged iron and steel, beeswax,
cotton, leather, and human hair
28 × 18 × 20 inches
(71.1 × 45.7 × 50.8 cm)

Damien Hirst
b. Bristol, United Kingdom, 1965

Is Nothing Sacred, 1997
Glass, painted MDF, ramin, steel, nickel-plated steel, aluminum, sliding door locks with key, and pharmaceutical packaging
72 × 108 × 9 inches
(182.9 × 274.3 × 22.9 cm)

Barbara Kruger
b. Newark, NJ, 1945

Untitled (You Are Not Yourself), 1982
Gelatin silver print
72 × 48 inches (182.9 × 121.9 cm)

Untitled (I Shop Therefore I Am), 1987
Photographic silkscreen on vinyl
111 5/8 × 113 1/4 × 2 1/2 inches
(283.5 × 287.7 × 6.4 cm)

Louise Lawler
b. Bronxville, NY, 1947

Pollock and Tureen, Arranged by Mr. & Mrs. Burton Tremaine, Connecticut, 1984
Cibachrome print
28 1/8 × 39 inches
(71.4 × 99.1 cm)

Does Andy Warhol Make You Cry?, 1988
Cibachrome print and Plexiglas wall label
Photograph: 27 1/4 × 39 1/8 inches
(69.2 × 99.4 cm)
Wall label: 4 1/8 × 6 1/8 inches
(10.5 × 15.6 cm)

Does Marilyn Monroe Make You Cry?, 1988
Cibachrome print and Plexiglas wall label
Photograph: 27 1/4 × 39 1/8 inches
(69.2 × 99.4 cm)
Wall label: 4 1/8 × 6 1/8 inches
(10.5 × 15.6 cm)

Sherrie Levine
b. Hazleton, PA, 1947

La Fortune (After Man Ray): AP1, 1990
Felt, mahogany, and resin
33 × 116 × 65 1/2 inches
(83.8 × 294.6 × 166.4 cm)

Fountain (After Marcel Duchamp): 1, 1991
Bronze and artist's wooden base
14 × 25 × 14 1/4 inches
(35.6 × 63.5 × 36.2 cm)

Black Newborn: 1, 1994
Cast and sandblasted glass on grand piano
5 1/2 × 8 × 5 inches
(14 × 20.3 × 12.7 cm)

Crystal Newborn: 4, 1993
Cast and sandblasted glass on grand piano
5 1/2 × 8 × 5 inches
(14 × 20.3 × 12.7 cm)

Richard Prince
b. Canal Zone, Panama, 1949

Untitled (three women looking in the same direction), 1980
Ektacolor photographs
20 × 24 inches (50.8 × 61 cm) each

Richard Prince and Cindy Sherman
b. Canal Zone, Panama, 1949
b. Glen Ridge, NJ, 1954

Untitled (Richard Prince and Cindy Sherman), 1980
Ektacolor photographs
20 × 24 inches (50.8 × 61 cm) each

Charles Ray
b. Chicago, IL, 1953

Untitled (Tractor), 2003–2005
Cast aluminum
55 1/2 × 118 × 60 inches
(141 × 299.7 × 152.4 cm)

Cindy Sherman
b. Glen Ridge, NJ, 1954

Untitled Film Still, 1977
Gelatin silver print
40 × 30 inches (101.6 × 76.2 cm)

Untitled Film Still, 1979
Gelatin silver print
30 × 40 inches (76.2 × 101.6 cm)

Jeff Wall
b. Vancouver, Canada, 1946

The Destroyed Room, 1978
Transparency in light box
62 ⅝ × 92 ⅛ inches
(159 × 234 cm)

An Eviction, 1988/2004
Transparency in light box
90 ⅛ × 163 inches
(229 × 414 cm)

Rear view, open-air theatre,
Vancouver, 2005
Transparency in light box
89 × 115 ⅜ inches
(226.1 × 293.1 cm)

Credits

Photography by Tim Nighswander/IMAGING4ART. Additional photography by Alex Jamison, p. 22. Unless otherwise noted, all works are part of the Glenstone collection.

Thomas Demand

© 2011 Artists Rights Society (ARS), New York / VG Bild-Kunst, Bonn: *Leuchtkasten* [Light Box], 2004, pp. 52 (detail), 58–59; *Grotto*, 2006, pp. 22 (detail), 60–61

Marcel Duchamp

© 2011 Artists Rights Society (ARS), New York / ADAGP, Paris / Succession Marcel Duchamp: *Étant donnés: 1° la chute d'eau, 2° le gaz d'éclairage… (Given: 1. The Waterfall, 2. The Illuminating Gas…)*, 1946–66, mixed media assemblage: (exterior) wooden door, iron nails, bricks, and stucco; (interior) bricks, velvet, wood, parchment over an armature of lead, steel, brass, synthetic putties and adhesives, aluminum sheet, welded steel-wire screen, and wood; Peg-Board, hair, oil paint, plastic, steel binder clips, plastic clothespins, twigs, leaves, glass, plywood, brass piano hinge, nails, screws, cotton, collotype prints, acrylic varnish, chalk, graphite, paper, cardboard, tape, pen ink, electric light fixtures, gas lamp (Bec Auer type), foam rubber, cork, electric motor, cookie tin, and lino-leum, 95½ × 70 × 49 inches (242.6 × 177.8 × 124.5 cm), Philadelphia Museum of Art. Gift of the Cassandra Foundation, Photo: Graydon Wood, p. 41

Peter Fischli David Weiss

© Peter Fischli David Weiss / Courtesy Matthew Marks Gallery: *The Objects for Glenstone*, 2010–11, cover flap (detail), pp. 62–71

Katharina Fritsch

© 2011 Artists Rights Society (ARS), New York / VG Bild-Kunst, Bonn: *Mönch* [Monk], 1997–99, pp. 14, 72, 77 (detail); *Doktor* [Doctor], 1997–99, pp. 14, 72, 75 (detail); *Händler* [Dealer], 2001, pp. 14, 44 (detail), 73, 74 (detail); *Herz mit Geld und Herz mit Ähren* [Heart with Money and Heart with Wheat], 1998–99, pp. 6–7, 25 (detail), 78–81; 1987 installation of Katharina Fritsch, *Madonnenfigur* [Madonna Figure], 1982, Photo: Rudolf Wakonigg, p. 46

Robert Gober

© Robert Gober / Courtesy Matthew Marks Gallery: *The Kaleidoscopic Sink*, 1985, pp. 9, 85; *The Silly Sink*, 1985, pp. 8, 83; *Two Urinals*, 1986, pp. 38 (detail), 87; *Untitled*, 1987, pp. 9, 89; *Going For The Cheese*, 1992–93, pp. 90 (detail), 91; *Untitled*, 2006–2007, pp. 13 (detail), 93; *Leg with Anchor*, 2008, cover, pp. 15, 95

Damien Hirst

© 2011 Damien Hirst and Science Ltd. All rights reserved, Artists Rights Society: *Is Nothing Sacred*, 1997, pp. 96–97

Barbara Kruger

© Barbara Kruger / Courtesy Mary Boone Gallery, New York: *Untitled (You Are Not Yourself)*, 1982, pp. 16, 98; *Untitled (I Shop Therefore I Am)*, 1987, p. 99

Louise Lawler

© Louise Lawler / Courtesy of the artist and Metro Pictures: *Pollock and Tureen, Arranged by Mr. & Mrs. Burton Tremaine, Connecticut*, 1984, pp. 26 (detail), 31, 101; *Does Andy Warhol Make You Cry?*, 1988, pp. 102–103; *Does Marilyn Monroe Make You Cry?*, 1988, pp. 104–105

Sherrie Levine

© Sherrie Levine / Courtesy Paula Cooper Gallery, New York: *La Fortune (After Man Ray): AP1*, 1990, pp. 30–31, 106–107; *Fountain (After Marcel Duchamp): 1*, 1991, pp. 30, 109; *Crystal Newborn: 4*, 1993, pp. 6, 110–111, 113; *Black Newborn: 1*, 1994, pp. 6, 110, 112

Man Ray

© 2011 Man Ray Trust / Artists Rights Society (ARS), New York / ADAGP, Paris: *La Fortune*, 1938, oil on canvas, 24 × 29 inches (61 × 73.7 cm), Whitney Museum of American Art, New York; Purchase, with funds from the Simon Foundation, Inc. 72.129. Photo: Sheldon C. Collins, p. 37

Richard Prince

© Richard Prince / Courtesy Gagosian Gallery: *Untitled (three women looking in the same direction)*, 1980, pp. 17, 114–115; *Untitled (Richard Prince and Cindy Sherman)*, 1980, pp. 116–117